SCOTTI

LIGHTHOUSES

AN ILLUSTRATED HISTORY

Michael A. W. Strachan

AMBERLEY

First published 2016

Amberley Publishing
The Hill, Stroud
Gloucestershire, GL5 4EP

www.amberleybooks.com

British Library Cataloguing in Publication Data.
A catalogue record for this book is available from the British Library.

ISBN 978 1 4456 5839 1 (print)
ISBN 978 1 4456 5840 7 (ebook)

Typesetting and Origination by Amberley Publishing.
Printed in Great Britain.

Contents

Introduction

The coastline of Scotland, including the Orkneys, Shetlands and Western Isles, amounts to a staggering 10,000 miles. Astonishingly, for an island nation whose wealth lay over and under the waves, these coasts were in relative darkness, bar primitive fires, until well into the second half of the eighteenth century. Shipwrecks were frequent, lost with lives and the wealth of the nation.

England's coasts had been protected by the lights of Trinity House since 1514, but Scotland would not have a dedicated national lighthouse service until 1786. From that date, the Northern Lighthouse Board (NLB) has lit up Scotland's coasts with the construction and reconstruction of over ninety major lights and countless minor lights, buoys, and beacons.

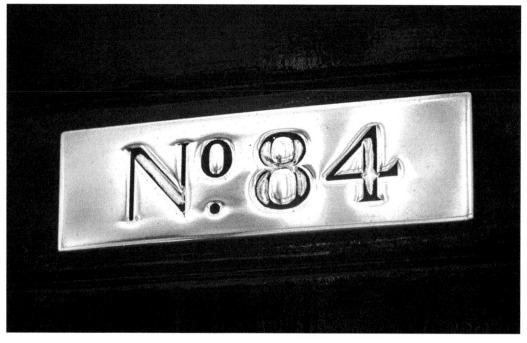

(Keith Allardyce, Collection of the Museum of Scottish Lighthouses)

4

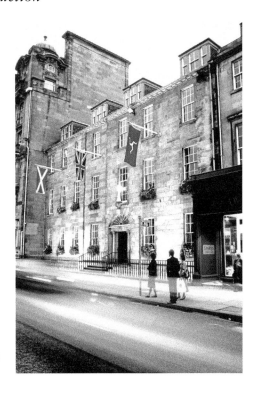

84 George Street, Edinburgh: the offices
of the Northern Lighthouse Board. (Keith
Allardyce, Collection of the Museum of Scottish
Lighthouses)

From 84 George Street, the Commissioners of Northern Lighthouses and their engineers led the world in lighting the seas. For over 150 years, the Stevenson engineers pioneered their own innovative new technologies and, with their enlightened minds, exported and imported the best ideas the world had to offer. The Stevensons' mark on Scottish lighthouses is so indelible; this short history often reads like a family history.

The Stevensons are, though, only one part of the larger picture. The Scottish lightkeeper held his post marking the seas for over 210 years, undertaking nightly vigils to protect the mariner. Often posted to some of the most remote areas of Scotland, life could be lonely not only for them but also for the families who would follow them from post to post. As was frequently said, 'It was not a job, it was a way of life.'

With the full-scale automation of Scotland's lighthouses, it is now a way of life that has been lost. The technological advances that succeeded the Stevensons saw the keepers redundant, replaced by machines that could undertake the jobs of humans. As one keeper reflected on his own forced retirement, 'These days the lights still flash … but there's nobody there.'

While the keepers may be gone, the NLB, led from number 84, continues to maintain Scotland's lights standing on the shoulders of the Stevensons: constantly innovating, constantly updating, always to the best value to the mariner. Through all these years, they have been guided by the same motto: *In Salutem Omnium* – 'For the Safety of All'.

Making use of the archives and imagery of the Museum of Scottish Lighthouses, this book will give an account of that service. While the Board advances into the future, the Museum, and others like it, has the task of preserving the past and remembering the men who served and shaped the service over its so far short but illustrious history.

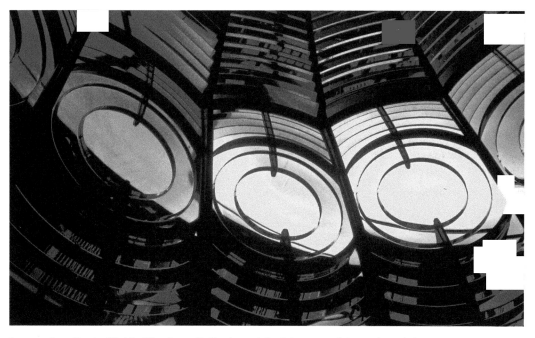

Lens at Bass Rock. (Keith Allardyce, Collection of the Museum of Scottish Lighthouses)

The motto of the Northern Lighthouse Board is *In Salutem Omnium* ('For the Safety of All'). (Keith Allardyce, Collection of the Museum of Scottish Lighthouses)

Chapter 1

The First Lights

By the middle of the eighteenth century, the Scottish coast was lit by only two solitary primitive beacons. The first was built on the Isle of May in 1636. It was a substantial three-storey, 40-foot tower. On the top of the tower was a huge brazier that would burn through 400 tons of coal annually. Open to the elements, the effectiveness of the light was questionable although it survived into the early nineteenth century.

The second light was built by the newly formed Clyde Lighthouse Trust in 1757. The Little Cumbrae Lighthouse, on the Firth of Clyde, was a plain circular tower that like the May beacon would burn an open coal fire on top, to the same unreliable effect.

These lights, although welcome, were quite inadequate for protecting the mariner. After a severe winter in 1782, the Scottish MP George Dempster successfully argued for the creation of a Scottish lighthouse authority in 1786. Originally tasked with building only four lights, the Board would go on to build all coastal lights around the whole of Scotland and the Isle of Man.

The coal beacon at the Isle of May was saved as a ruin by Sir Walter Scott in 1816. (Peattie Collection, Museum of Scottish Lighthouses)

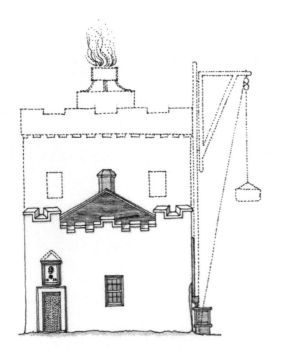

Drawing of the coal beacon showing the remains in comparison to the full structure with coal fire on top. (Collection of the Museum of Scottish Lighthouses)

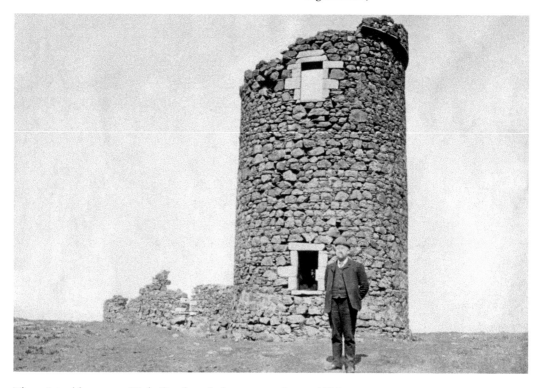

The original beacon at Little Cumbrae before restoration *c.* 1905.

Etching of George Dempster MP.

Establishment of the Northern Lighthouse Trust

The Trustees of the Northern Lighthouses were established by an Act of Parliament in 1786, tasked with building four lighthouses to illuminate some of Scotland's most perilous waters. This first act gave the Trustees the power to purchase land, levy dues and borrow funds. The act allowed for the Trustees to borrow £1,200 to build their lights, a wholly inadequate sum for the project before them.

The Board's income was collected through a charge on shipping, but they could only collect the income when all four of the proposed lights were operational. These lights were to be built at Kinnaird Head, the Mull of Kintyre, Eilean Glas and North Ronaldsay.

The Board struggled to find a builder, but by act of fate they found the man who would provide brilliant illumination to the service. This man was Thomas Smith, a lamp maker in Edinburgh.

Smith had designed a parabolic reflector for the Trustees of Manufactures in Scotland with the remit of improving navigation around the Firth of Forth. Happily, his lighting device came to the attention of the Trustees of the Northern Lighthouses. It was on this basis, and this basis alone, that he secured his appointment as engineer to the Board.

Lighthouse Illuminant

Smith's parabolic reflector comprised a whale oil lamp set into a domed parabolic mirror. The reflector was made up of small squares of highly polished tin (latterly replaced by facets of highly polished glass), all domed around a multi-wick lamp. An oil reservoir was fitted behind the reflector in order to provide a constant supply of whale oil to saturate the wicks to keep the light burning.

The principle of the parabolic reflector was simple: the wick would be lit and the light reflected forward by the highly polished mirrored glass. The device was brilliant in its innovation and would go on to make the first Scottish lights among the most powerful of their time.

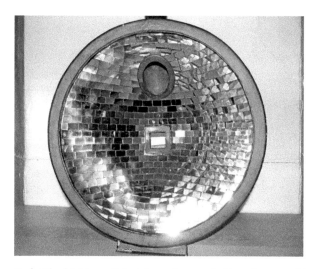 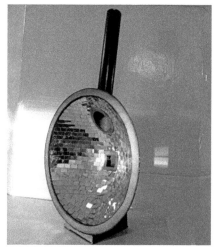

Left: The highly polished face of a parabolic reflector with recess for oil reservoir. (Collection of the Museum of Scottish Lighthouses)

Right: Side view of Smith's parabolic reflector, showing the Argand chimney feature. (Collection of the Museum of Scottish Lighthouses)

Smith would still require a degree of training in lighthouse engineering. In early 1787, Ezekiel Walker, an English lighthouse-builder who had been recommended to the Trustees, offered to build one lighthouse himself and to give instruction on the other three. In the same letter, he offered to instruct any person of the Trustee's choosing in the art of lighthouse engineering for fifty guineas.

The Northern Lighthouse Trustees, being short on capital and having been suitably impressed by his reflector, went with the cheaper offer and with little delay Smith was sent off to Norfolk to be instructed by Walker.

This would be a crash course in engineering with Smith arriving back in Edinburgh after a matter of weeks in March 1787. A month later, Thomas Smith, the lamp maker from Edinburgh, travelled north to Fraserburgh to start construction on Scotland's first lighthouse.

The First Lighthouse and Keepers

The land and site for the first lighthouse had been acquired some months before Smith's appointment as engineer to the Northern Lighthouse Trust. From the outset, the Trustees planned to acquire the castle of Kinnaird Head in Fraserburgh.

Considering Smith's lack of engineering experience and the need for the lights to be built quickly, the tower at Kinnaird Head proved a practical solution. Smith was to make use of the ready built castle tower, making only the structural alterations required to support a lantern. The top part of the castle tower was demolished in order to create a flat surface on which the new lantern was to sit.

The new roof of the tower was strengthened and fireproofed before the new lantern was finally constructed in the same corner where the current lantern sits today. All the

structural works were completed by November 1787 and Smith's parabolic reflectors installed into the new lantern. In total, seventeen reflectors were installed.

Smith had now constructed the lighthouse and provided the technology to light it, but it was still in his remit to employ and, more importantly, to train the first keepers.

When appointing the first keepers, Smith preferred candidates to have a seafaring background, employing ships' captains and experienced mariners. His personal choice for Kinnaird Head would be James Park who was a retired master mariner.

Park was paid a shilling the night and was given the right to graze a cow on the lighthouse ground on condition that he always had a second person with him through the night. Surprisingly, Park was about seventy years old when he started his career in the lighthouse service. For a man of that age in that time, his duties were not light.

Smith instructed Park in how to keep the light burning all night and in maintaining the greatest brilliancy of light from the reflectors. Park was to take great care when affixing the wicks into the lamp so that they were neither too tight nor too slack. If they were too tight, it could suppress the supply of oil, and if too slack they may sink into the burner.

He would refill the lamps with whale oil every morning and clean the reflectors and lantern panes every morning, wiping off all oil and smoke that may cling to them. They had to be cleaned daily to maintain brilliancy and to prevent fire. The lamps were to be lit 'half an hour after Sun-seting *[sic]* and keep them burning till half an hour before Sunrising every day', attending them every two or three hours throughout the night.

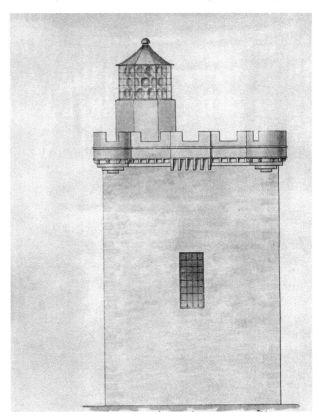

Drawing of Kinnaird Head Lighthouse with Thomas Smith's lantern containing seventeen parabolic reflectors. (Collection of the Museum of Scottish Lighthouses)

After Kinnaird Head, the other three lights followed in quick succession with Smith being assisted by his young apprentice and stepson, Robert Stevenson. Mull of Kintyre was lit in 1788 with the lights at Eilean Glas (Scalpy) and North Ronaldsay being illuminated in October 1789. All lights were lit using Smith's system of parabolic reflectors. With the completion of these lights, the Trustees had concluded their original remit.

Oil reservoir and wicks for parabolic reflector.

Remains of Thomas Smith's small lighthouse tower at Eilean Glas. (Ian Peattie Collection, Museum of Scottish Lighthouses)

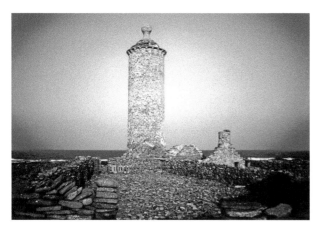

Smith's lighthouse tower at North Ronaldsay. (Ian Peattie Collection, Museum of Scottish Lighthouses)

Chapter 2

National Establishment

Robert Stevenson continued to assist his stepfather for the rest of the latter's career in the lighthouse part of the business, contributing to six lights including Inchkeith and Start Point. The young Stevenson proved his mettle overseeing the building of his first light at Little Cumbrae on behalf of Clyde Lighthouses in 1793. He completed his first light for the Commissioners of Northern Lighthouses, acting as superintendent, at Pentland Skerries the following year.

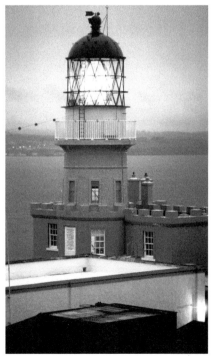

Left: Portrait of Robert Stevenson (1772–1850).

Right: Robert assisted his father with the building of the Inchkeith Lighthouse. (Keith Allardyce, Collection of the Museum of Scottish Lighthouses)

Plaque at Inchkeith
Lighthouse. (Keith Allardyce,
Collection of the Museum of
Scottish Lighthouses)

These attributes saw him appointed joint engineer to the Board with Thomas in 1797, becoming sole engineer in 1808. By then, he had already started work on the light that would make his and his family's name: the Bell Rock.

Bell Rock

Situated 12 miles off the coast of Arbroath, the Inchcape Rock had been a danger to the mariner for centuries. The loss of HMS *York* with the loss of all hands in 1804 helped push through the Act of Parliament which led to the lighthouse's construction. Building on a reef would not be a first: the famed John Smeaton had built on the Eddystone Rock, some 14 miles off Portsmouth, fifty years earlier in 1759. There was one major difference: Eddystone was barely covered by the tide at high water, while the Bell Rock was barely exposed in low water.

Work on site would only be possible during low tide and only during the summer months when weather allowed it. The men would therefore spend much of their time on board their boat the *Smeaton*, or latterly on the barracks they built on the reef.

The groundwork began in August 1807, preparing the reef for building. The foundations were 'dug out' by pickaxe by sixty men for twenty hours a day. It was feared that blasting may cause unintended damage. When the tide came twice daily, the foundation pit would flood and require pumping.

The next summer, the reef underwent more preparatory work with Stevenson constructing cranes on the landing place to winch the stones from the boats. Building also began on a mini-railway that ran from the landing cranes right round the circumference of the foundation pit, making it easier to transport the granite stones.

Following the lead of Smeaton, the stone courses (or layers) of the foundations were cut to interlock. In Stevenson's words, 'each course or tier of this building connected or let into one another by a system of dovetails diverging from the centre to the circumference'. This was undertaken to strengthen the foundations that would be lashed by the tides. This meant every stone had to be cut to precision on the shore before being transported to the reef.

So precise was the work that no cut stone was sent back to land. All were perfectly cut and slotted into their intended places.

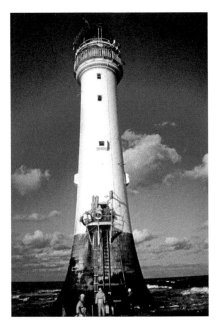
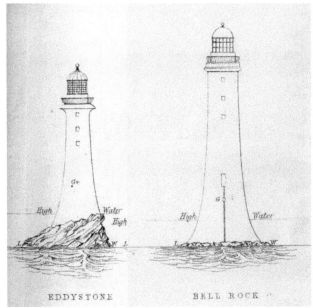

Left: Stevenson's Bell Rock is the oldest sea-washed tower in the world. (Keith Allardyce, Collection of the Museum of Scottish Lighthouses)

Right: Compared to Smeaton's Eddystone, the Bell Rock reef was submerged significantly more during the high tide.

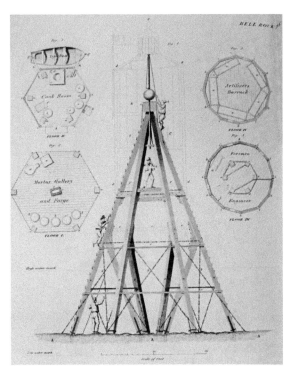

A temporary barrack was built on the reef to save time landing men on and off with the tide. (From Robert Stevenson's *An Account of the Bell Rock Light-House*)

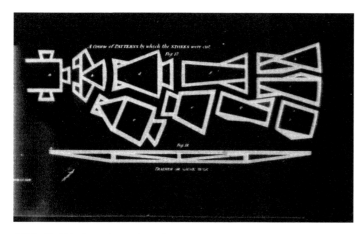

The interlocking pattern through the courses of the Bell Rock were designed to strengthen the structure. (From Robert Stevenson's *An Account of the Bell Rock Light-House*)

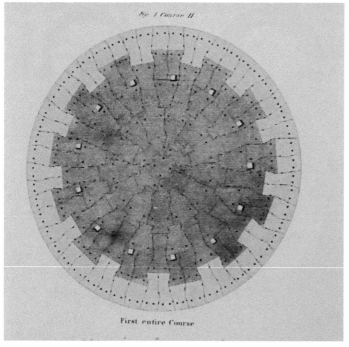

The full first course of the Bell Rock Lighthouse. (From Robert Stevenson's *An Account of the Bell Rock Light-House*)

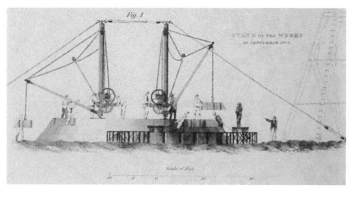

State of works in September 1808. (From Robert Stevenson's *An Account of the Bell Rock Light-House*)

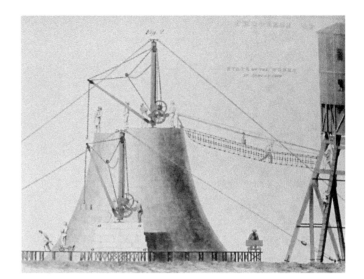

State of works in August 1809. (From Robert Stevenson's *An Account of the Bell Rock Light-House*)

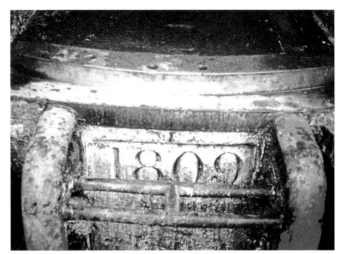

1809 date stone on Bell Rock tower door. (Ian Peattie Collection, Museum of Scottish Lighthouses)

After two years' work, on 30 June 1809, the tower rose high enough to be above high tide for the first time. Under a month later, after twenty-six courses, the solid granite base of the tower rose to 31 feet 6 inches above the foundation. It would take sixty-four more courses of sandstone bricks built on top of the granite base for the tower to be completed, which was achieved in July 1810. It was noted that all 2,500 granite blocks had been pulled to the boats by one horse called Bassey.

The light was exhibited officially for the first time on 1 February 1811, using Stevenson's improved array of reflectors with sheets of copper instead of tinplate glass.

The building project would continue into 1813 on land with the construction of the Signal Tower at Arbroath. This first shore station was the official residence of the station boatman who would attend to the Bell. Signalling with a ball on a mast, the keepers on the Rock were able to communicate with the Tower. The site was also the residence of the keepers and families who served the rock until the 1970s. It is now a museum dedicated to the Bell Rock Lighthouse.

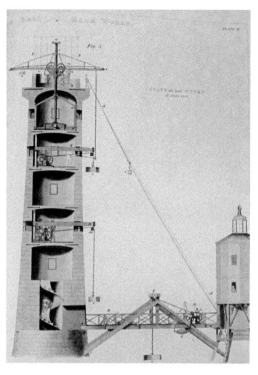

State of works in July 1810. (From Robert Stevenson's *An Account of the Bell Rock Light-House*)

'Bassey the horse' was famed for pulling every stone to the boats. After her death, her skeleton was preserved. (From Robert Stevenson's *An Account of the Bell Rock Light-House*)

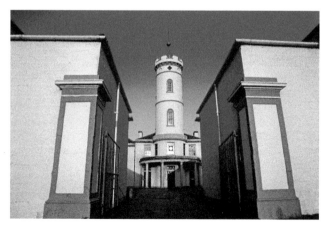

Signal Tower in Arbroath was built for a dedicated boatman and as keepers' accommodation. (Keith Allardyce, Collection of the Museum of Scottish Lighthouses)

Distinction among Lights

As has been alluded to already, in addition to civil engineering, Robert held an interest in improving lighthouse illumination. Not only did he improve the brilliancy of the reflector lamps but he also pioneered new technologies to make lights distinguishable from one another. With the number of lights increasing, they would now need to be distinguishable from each other for safe navigation.

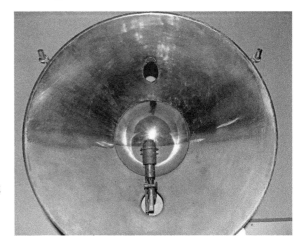

Stevenson's reflectors were made using silvered sheets of copper, improving the brilliancy of light. (Collection of the Museum of Scottish Lighthouses)

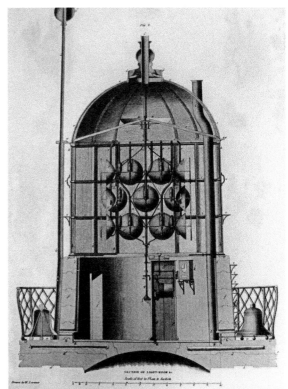

Bell Rock lantern and the revolving reflector frame, showing the clockwork machine. (From Robert Stevenson's *An Account of the Bell Rock Light-House*)

He installed the first revolving apparatus at Start Point, Orkney, as early as 1806. This was achieved by spinning the reflector's frame and arranging the reflectors in a particular sequence to create a flash effect. The same technology was erected in the tower of the Bell Rock in 1810, regulated by a clockwork winding machine.

Robert invented two types of flashing lights of note. The first was the 'intermittent' light where a flash was caused by the opening and closing of metal shades that surrounded the reflector frame. The second, and more celebrated, was the 'flashing' light (as opposed to occulting) where the lamp frame would spin in quick revolutions, creating a sudden flash every five seconds or so.

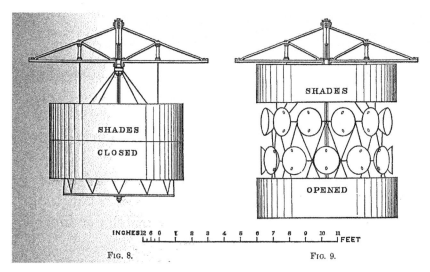

Diagram: Robert Stevenson's system of shutters to create a flashing light.

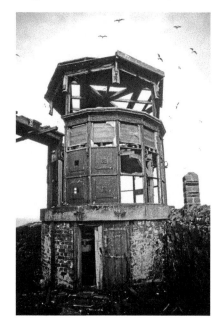

Ruins of Robert Stevenson's experimental tower at Inchkeith. (Keith Allardyce, Collection of the Museum of Scottish Lighthouses)

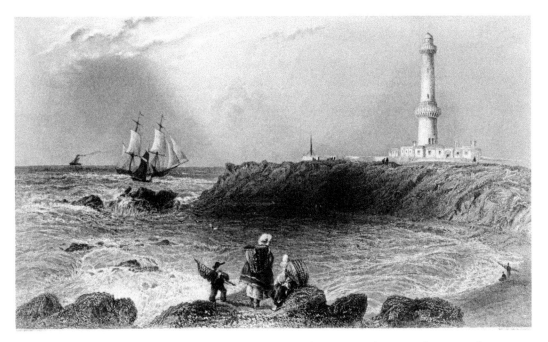

Image of Girdle Ness Lighthouse, depicting the two lanterns on the tower, by E. J. Roberts.

These experiments were carried out at Inchkeith where he had a specially built test lantern constructed.

Another example of distinction between lights is evidenced in the construction of the tower he built at Girdle Ness, Aberdeen (1833). This light would be recognisable by a double light, one being in the top lantern and a second light shining about a third of the way up the tower. The bulge can still be seen today even though the low lantern was sealed in 1890 when the top apparatus was upgraded to a flashing light.

National Establishment

By 1811, the NLB had reached maturity and had proven itself as a serious lighthouse authority. As part of their National Establishment Policy, Robert returned to many of the lights he and Thomas Smith had built in order to raise them to permanence. His stepfather's lantern at Kinnaird Head was removed, Stevenson replacing it with a new lighthouse tower built through the original castle in 1824. The Mull of Kintyre (1830), Eilean Glas (1824) and Pentland Skerries (1833) were all rebuilt.

Perhaps his masterpiece on land was the new Isle of May light, which would replace the old coal beacon. Built in 1816, this highly styled building with its ornate gothic windows and castellations is built to look like a castle. Its appearance was no mistake: this was the Commissioners' light, where they would meet annually to discuss their business.

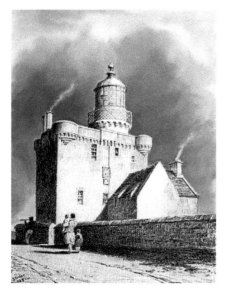

In 1823–24, Robert revisited Kinnaird Head Lighthouse and built a lighthouse tower through the castle.

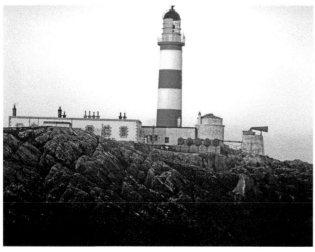

Robert Stevenson's new tower at Eilean Glas towering over that of his step-father. (Keith Allardyce, Collection of the Museum of Scottish Lighthouses)

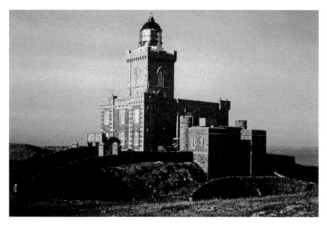

Isle of May Lighthouse exterior. (Ian Peattie Collection, Museum of Scottish Lighthouses)

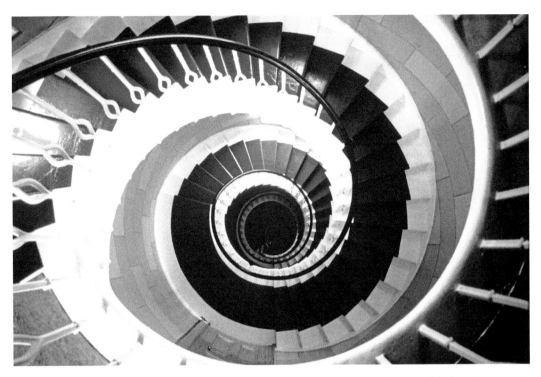

Open spiral staircases such as at the Isle of May were a common feature of Robert Stevenson's lights. Later staircases tended to be enclosed. (Keith Allardyce, Collection of the Museum of Scottish Lighthouses)

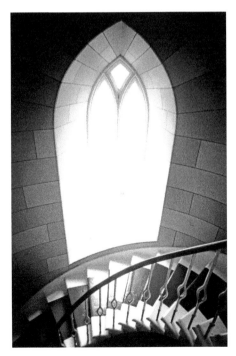

Interior of a gothic style window at the Isle of May. (Keith Allardyce, Collection of the Museum of Scottish Lighthouses)

Chapter 3

Godly Designs

Alan Stevenson (1807–65). (By kind
permission of the Stevenson Family)

With the retirement of Robert, his eldest son Alan was appointed to the post of engineer
to the Board. He had been groomed for the lighthouse service by Robert, who was keen
to ensure his son followed a proper trade. Alan was the intellectual of the family, whose
true interests lay in the classical world, but through his training he became a giant and
genius of lighthouse engineering.

Work with Lenses

As an assistant to his father, Alan's early interests included the development of
lighthouse lenses, pioneered by his friends and correspondents Augustin and Leonel
Fresnel. Augustin was the first to develop lens technologies as a means of lighthouse

illumination, producing the first bullseye lens panels in 1821. Robert Stevenson was impressed with the lens apparatus but Scotland's lighthouses would only install their first lens in 1835 at Inchkeith.

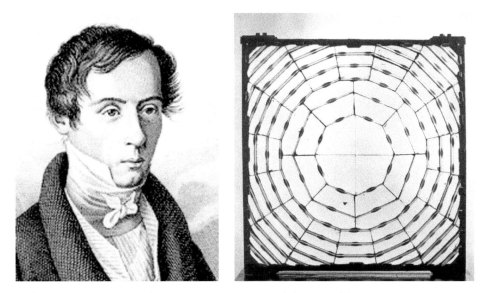

Left: Augustin-Jean Fresnel (1788–1827), inventor of the Fresnel lens.

Right: One of Fresnel's early bullseye panels of 1821.

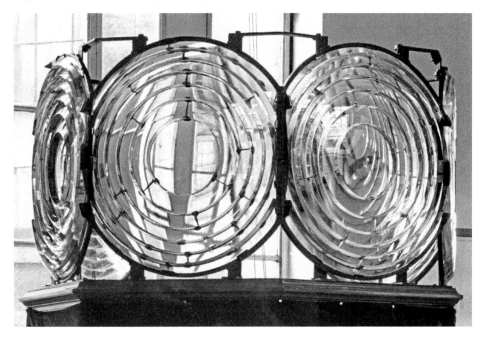

The lens belt installed at Inchkeith in 1835. Now part of the Collection of the National Museum of Scotland.

Seven lens panels produced by the Cookson factory in Newcastle were used to create the flashing light at the station. A second apparatus followed in 1836 for the Isle of May. These were introduced during Robert's tenure and so he would receive much of the credit for his son's endeavours.

As Bella Bathurst points out in her publication *The Lighthouse Stevensons*, due to the quality of their design Leonel Fresnel had advised the Stevensons to 'wait until your reflectors are worn out and then replace them with lenses'. Along with the cost (about £450 per new lens), this would mean a very gradual introduction to Scottish lights.

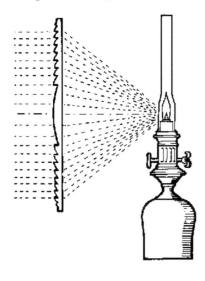

Bending light into the horizontal

Lenses work by magnifying the original light source, and by refracting light into beams. Refraction became more important as prisms were developed into the lens structures.

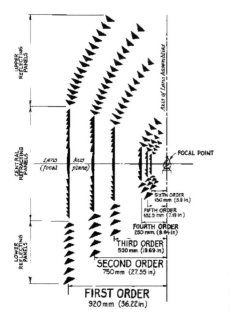

Lenses came in different sizes, from the largest First Order to the smallest Sixth Order. The greater the distance from the focal point, the larger the order.

Skerryvore

Alan was being noticed and, by 1837, he was serving as the Clerk of Works to the NLB. When he succeeded his father in 1843, he was already in the finishing stages of his own great masterpiece and obsession: the Skerryvore Lighthouse.

A lighthouse had been planned for Skerryvore by an Act of Parliament as far back as 1814. However, as Sir Walter Scott pointed out, this would be no easy task: 'It will be a most desolate position for a lighthouse – the Bell Rock and Eddystone a joke to it!'

Skerry Vhor, Gaelic for 'Great Rock', is located about 12 miles off the island of Tiree on the west coast of Scotland. Construction began in the summer of 1838 and continued for a full six years. Construction was difficult due to the weather conditions of the course and jagged rock. When Alan returned to the site for the second summer of building in 1839, the barracks and much of the work undertaken the previous year had been washed away by the strength of the waves.

The tower, the tallest in Scotland at 48 m, was completed and lit on 1 February 1844. The tower was built to a hyperbolic curve that focussed the centre of gravity at the lowest possible point on the structure. This design was imperative to the stability of the structure, ensuring endurance against the west coast waves, and it also gave the tower an elegant appearance. The lighthouse, to date, is often described as the most graceful light in the world.

While undertaking the Skerryvore project, Alan continued with his other obsession in improving the Fresnel lenses. Skerryvore was crowned with a first-order catadioptric rotating lens of eight panels, featuring for the first time Alan's prismatic lenses under the central lens belt. This increased the intensity of the beam as the most advanced of its time.

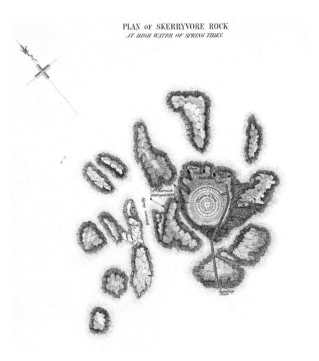

PLAN OF SKERRYVORE ROCK
AT HIGH WATER OF SPRING TIDES.

Plan of the Skerryvore reef.
(*Account of the Skerryvore Lighthouse*)

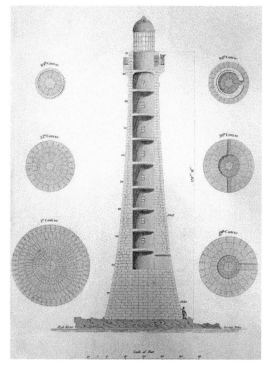

Drawing of the Skerryvore Lighthouse.
(*Account of the Skerryvore Lighthouse*)

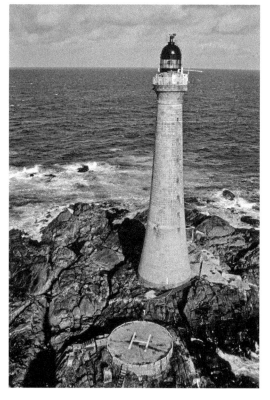

Skerryvore Lighthouse. (Keith Allardyce,
Collection of the Museum of Scottish
Lighthouses)

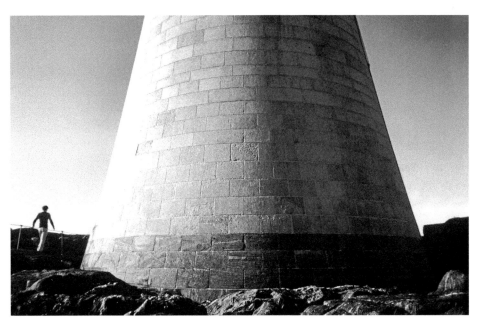

The smooth base of the Skerryvore tower. (Ian Peattie Collection, Museum of Scottish Lighthouses)

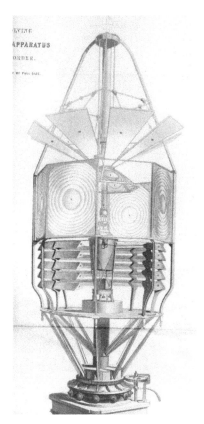

Alan Stevenson's revolving first-order lens for Skerryvore with prisms under the lens belt. The top panels still used mirrors, which made it a catadioptric lens. (*Account of the Skerryvore Lighthouse*)

Classical Influence

Alan was not, however, a man of pure practicality. His interest in the classical world often spilled out into his work, as can be seen by the design of the Skerryvore light. Although this copper and brass mechanical lamp is perfectly functional, it is decorated with four lion heads and stands on bull's feet.

This Greco-Egyptian influence would become a hallmark of Alan's architecture and intricate designs. At Covesea Skerries (1846) near Lossiemouth, the lighthouse lantern is supported on stone-carved, Egyptian-style long arches. Inside the lightroom, extremely practical brass air vents are finished with the haunting face of a Greek goddess. The fourth-order lens at Chanonry Point (1846) sat on a classical Greek-inspired pedestal.

At Noss Head (1849), Wick, Alan designed the lightkeeper cottages in an Egyptian style, with exaggerated elongated pillar-like chimneys and impressive decorative frontages.

Then came another masterpiece of Alan Stevenson: the building of Ardnamurchan Lighthouse (1849). That station is said to be Scotland's only truly Egyptian-style lighthouse, encompassing all of the above attributes. The 36-metre-high lighthouse was never painted, showing off the beautiful pink granite bricks cut for its construction.

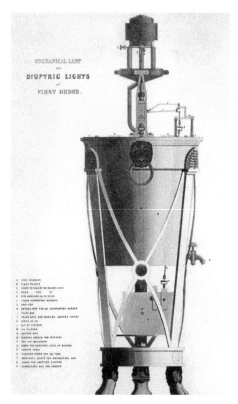 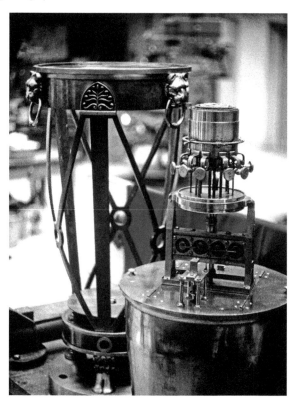

Left: Drawing of Alan Stevenson's stylised mechanical lamp. (*Account of the Skerryvore Lighthouse*)

Right: The decorative mechanical lamps were produced for a small number of lights during Alan's tenure and are exceptionally rare. (Collection of the Museum of Scottish Lighthouses)

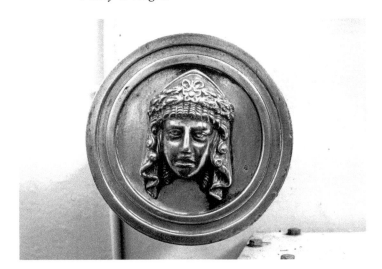

Air vent decorations featuring the goddess were used at most of Alan's lights.

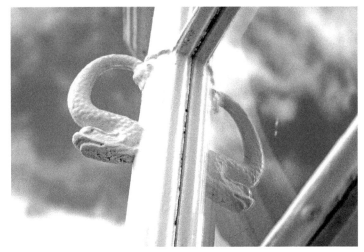

On a number of Alan's lanterns, the hand grips are stylised as serpents. (Keith Allardyce, Collection of the Museum of Scottish Lighthouses)

An example of Egyptian-style cottages at Noss Head with elongated pillar-style chimneys and stylised frontages. (Ian Peattie Collection, Museum of Scottish Lighthouses)

These features may well have been Alan's frustrations pouring out in his work as engineering had not been his first choice of career. Had it not been for his father, academia would have suited both him and his health better.

Although the Egyptian influence came and went in Scotland in a little over five years, it was Alan's obsession with creating the brightest lights possible that had the lasting impact on lighthouse architecture in Scotland. In 1849, he constructed the lantern at Noss Head with diagonal astragals as opposed to vertical.

Diagonal astragals made for a stronger triangular support structure. This meant the gunmetal could be made narrower than required in a vertical/horizontal structure, reducing interference to the beam. Practically, all lanterns since 1849 have diagonal astragals, making it a quintessential Scottish feature. Typically for Alan, his were decorated with brass lion heads.

Alan's tenure as engineer to the Board was short. He resigned his post in 1853 due to ill health. Alan had overseen the transition from reflectors to lenses in the majority of Scottish lights and as engineer he emerged from the shadow of his father, building and designing thirteen lighthouses in ten years – double the workload of Robert.

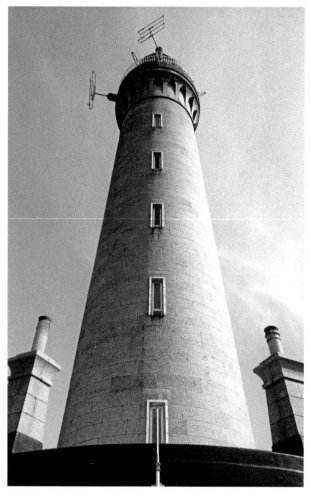

Ardnamurchan Lighthouse tower.
(Ian Cowe)

Design showing the diagonal astragals which became common in Scottish Lighthouses after 1849.

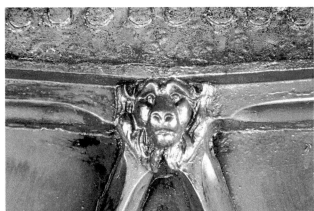

Lion's head decoration on the astragals on Girdle Ness. (Ian Peattie Collection, Museum of Scottish Lighthouses)

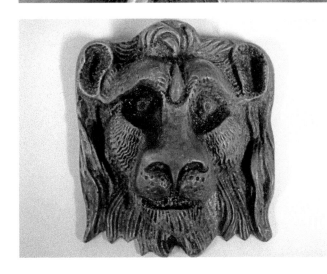

Detail of the brass decorative lion's heads used by Alan Stevenson. (Collection of the Museum of Scottish Lighthouses)

Chapter 4

Bright Lights

With Alan's early retirement, his younger brothers David and Thomas were appointed engineers to the Board. Of the two, David was the natural engineer and Thomas the inventor and innovator. The brothers would build over thirty lighthouses during their tenure to 1887, pioneering many new technologies.

Left: Photograph of David Stevenson (1815–85).

Right: Photograph of Thomas Stevenson (1818–87).

Remote Stations

The impressive works of their forebears would be matched by the brothers with the building of lights at some of Scotland's most remote and desolate rocks. The lighthouse at Muggle Flugga, the most northerly lighthouse in the British Isles, was an early sign of their talent. In Norse, the name means 'large steep-sided island', which perfectly describes how the light is perched high on the rocks. The light had been built from 1854 with the intention of aiding warships en route to Crimea.

The brothers added further to the number of Scotland's rock stations with the building of Chicken Rock, off the Isle of Man, in 1874. Dubh Artach, Skerryvore's neighbour, was built between 1867 and 1872. No keeper will have thanked them for building Dubh Artach, regarded as one of the worst stations in the service due to cramped and damp living conditions. A drop at Skerryvore was welcome compared to the alternative!

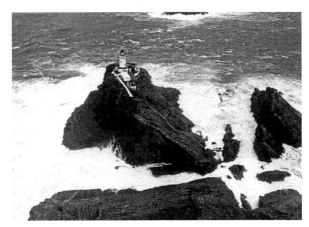

Muckle Flugga (N. Unst).

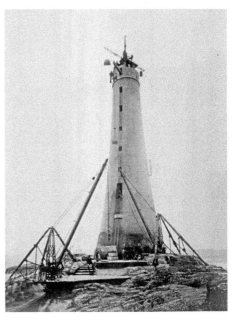

Building of Chicken Rock Lighthouse.

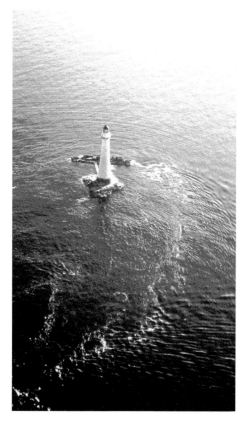

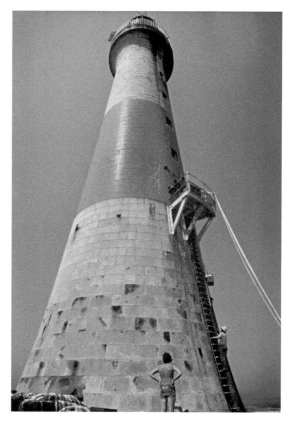

Left: Aerial image of Chicken Rock Lighthouse. (Ian Peattie Collection, Museum of Scottish Lighthouses)

Right: A red band was painted on the tower in 1906 to act as a day marker. (Keith Allardyce, Collection of the Museum of Scottish Lighthouses)

Illumination

Thomas' greatest contribution was in lighthouse illumination. It was noted that when Dubh Artach was lit in 1872, it was so bright that principal keeper Ewing requested special eye protection from the light.

After a series of experiments with the Doty paraffin burners from 1872, the Stevenson brothers introduced paraffin oil to all Scottish lights. They found that the paraffin operated 'at one half the cost give an increased luminous for an equal consumption'.

The NLB was the first lighthouse authority in the UK to adopt paraffin burners, giving an 'annual saving of between £4,500 and £5,000 in the maintenance of the lights on the Scotch coast'.

Thomas enjoyed a good working relationship with James Chance, who had founded a glass factory in Smethwick, Birmingham, in 1851. The Chance Brothers' factory was the only operating lens manufacturer in the UK and became a major supplier of lenses worldwide. In this collaboration, Thomas provided the 'inventive genius' where Mr Chance attempted to put his plans into practice.

The Chance factory produced some of the finest holophotal lenses designed by Thomas, which were used in new stations like St Abb's Head and Monach. These lenses had prisms above and below the lens panels, catching enough light to dispense with the catadioptric combination of glass and mirrors. The purpose of the holophotal lens, first devised in 1849, was to catch and refract as much of the original light in parallel with the central beam.

The Chance Factory near Birmingham produced the greatest number of higher order lenses for the Northern Lighthouse Board after 1851. (Keith Allardyce, Collection of the Museum of Scottish Lighthouses)

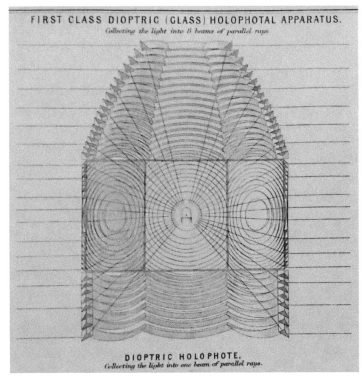

FIRST CLASS DIOPTRIC (GLASS) HOLOPHOTAL APPARATUS.
Collecting the light into 8 beams of parallel rays

DIOPTRIC HOLOPHOTE,
Collecting the light into one beam of parallel rays.

Diagram of how the holophotal lens caught the light to bend it in parallel with the central beam. (From Thomas Stevenson's *Lighthouse Illumination*)

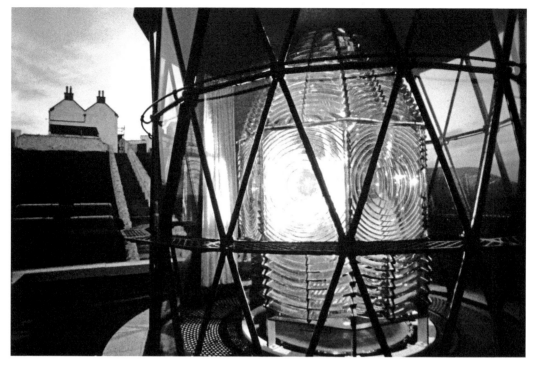

David and Thomas Stevenson's holophotal lens at St Abb's Head Lighthouse. (Keith Allardyce, Museum of Scottish Lighthouses)

Fog Signals

Despite the great advancements in illumination, the lighthouses were still made temporarily redundant in the fog. For all their power, they failed to penetrate the fogs which blanketed Scotland's coasts. Early attempts at combating the fog included firing guns and the use of bells to warn the mariner, as at the Bell Rock. They proved to be wholly inadequate.

The Commissioners were reluctant to introduce fog signals to Scotland and the Stevensons showed little interest in the technologies. When they were finally introduced, they were imported from America. The first NLB fog siren was introduced at St Abb's Lighthouse in the south-east of Scotland in 1876.

The gas-powered sirens at Ailsa Craig were of particular interest due to their construction at the north and south of the island at a great distance from the light. Foghorns would require an extra keeper for the additional duties, but due to the double sirens at the Craig, four men would be required.

As Munro wrote, 'siren, sounded by steam or compressed air, was the most powerful and characteristic signal yet devised'. Despite this, the early technology would only be heard for about 3 miles in adverse weather conditions.

Technology would quickly improve, with oil engines being introduced to drive air compressors at the turn of the twentieth century. Compressed air was channelled into air receivers to build the pressure, then channelled into a siren through a clockwork

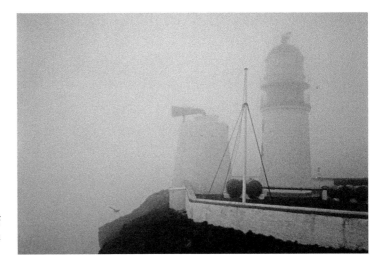

Copinsay Lighthouse in the fog. (Keith Allardyce, Collection of the Museum of Scottish Lighthouses)

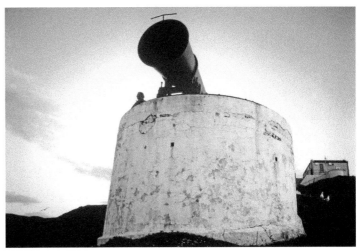

The foghorn at St Abb's Head was the first introduced to Scotland, in 1876. (Keith Allardyce, Collection of the Museum of Scottish Lighthouses)

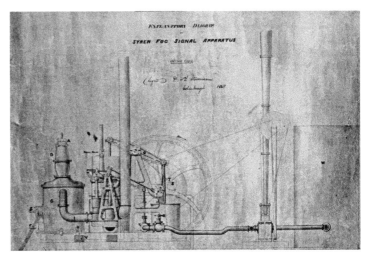

Diagram of the engines used to power the engines at St Abb's Head. (Collection of the Museum of Scottish Lighthouses)

Photograph of the foghorn engines at Ailsa Craig, 1911. (Peddie Collection, Museum of Scottish Lighthouses/NL Heritage Trust)

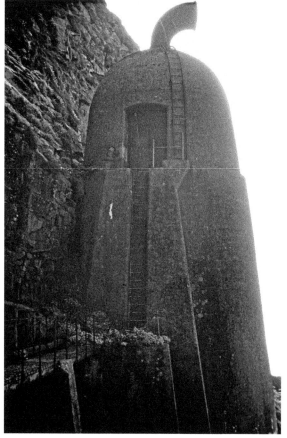

Due to the height of the land on the island, the Ailsa Craig horns were built at the base of the island away from the station. (Ian Peattie Collection, Museum of Scottish Lighthouses)

mechanism. In the 1950s, Kelvin-Diesel engines would be used that allowed the horn to be operational within four minutes of fog being spotted.

The clockwork mechanism was required to regulate the blast sequence. Just as lights were affixed a character, foghorns had a recognisable blast pattern that would often be heard upwards of 10 miles.

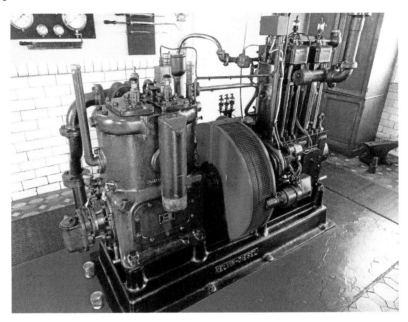

Kelvin-Diesel engines like these at Kinnaird Head were widely used to drive air compressors from the 1950s.

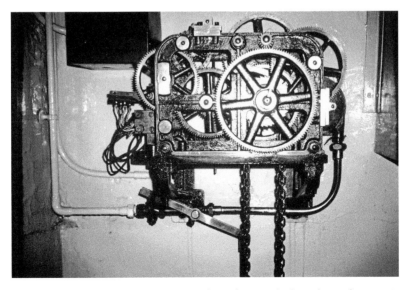

Blast patterns were regulated by a weight and air-driven clockwork mechanism in order to differentiate between stations. (Ian Peattie Collection, Museum of Scottish Lighthouses)

Electric Lights

Thomas Stevenson's last major achievement was to introduce an electric light to a major station. In 1886 he, with his nephew David, successfully exhibited an electric light from the Isle of May with great effect. The light was produced using a carbon arc lamp on which an electrical current passed between two rods. The electricity was produced by two huge steam-powered generators, which were powered by coal. The increase in work meant the station required three extra keepers, extra dwelling houses, a forge and an engine house at great expense.

The light was enhanced using another optical invention of Thomas: a condensing light of the second order. The light was intensified with a standing lens with a rotating surround of vertical prisms that refracted the light into a group flash sequence: four fast flashes every thirty seconds.

The light was more powerful than the paraffin of that time but operated poorly in the fog. Due to that, and the enormous expense, the electric light was removed in 1924 and reverted back to a paraffin lamp.

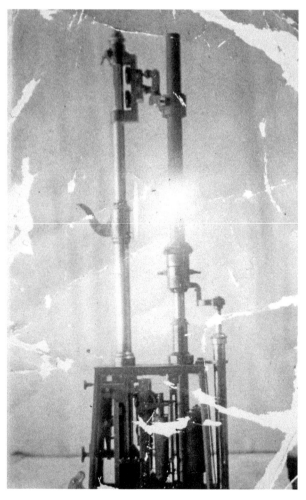

The carbon arc lamp at the Isle of May Lighthouses. (Collection of the Museum of Scottish Lighthouses)

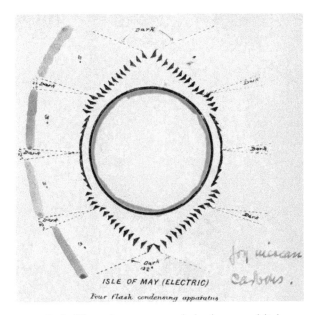
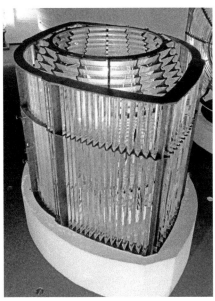

Left: The prisms separated the beams of light to create flashes, as shown in this diagram by D. Alan Stevenson.

Right: The Isle of May lens assembly of 1886 was extremely similar to this one from Fair Isle South (1892). The prisms revolved around a stationary lens. (Collection of the Museum of Scottish Lighthouses)

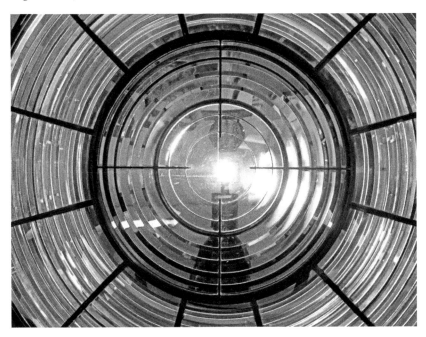

Due to the cost, the light reverted back to paraffin in 1924, aided by a first-order lens. (Collection of the Museum of Scottish Lighthouses)

Chapter 5

Into Modernity

The service under David Alan would be one of modernisation as the lighthouse service prepared for the twentieth century. In the same spirit of his forebears, he would continue to experiment and innovate. His brother Charles assisted him over the next fifty years.

David Alan Stevenson (1854–1938), Engineer to the Board 1885–1938.

Innovation

With his uncle, David oversaw the anchoring of Scotland's first manned light vessel, the *North Carr*, near the entrance to the Forth. The vessel was simply a floating light with a wooden hull and no engine – practically a manned buoy. The vessel would be upgraded in 1933 to a steel vessel boasting a group flashing fourth-order lens and a foghorn.

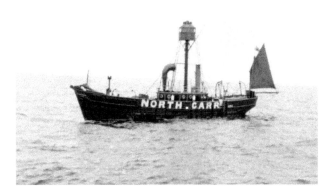

The old *North Carr*, pictured 1912, was described by David Alan as being more useful as a fog signal. (Peddie Collection, Museum of Scottish Lighthouses/NLHT)

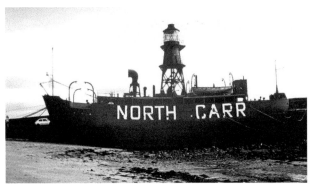

The upgraded *North Carr* of 1933 had no engine, but an improved optic. (Ian Peattie Collection, Museum of Scottish Lighthouses)

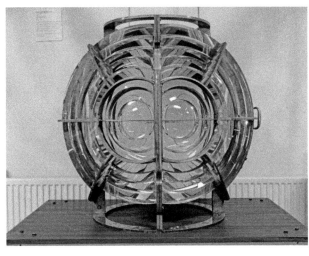

The 1933 fourth-order lens produced a double flash. (Collection of the Museum of Scottish Lighthouses)

As engineer, he also introduced the first automatic light to the Scottish service by removing the two keepers from the Oxcars Lighthouse in 1894. The light was operated with a gas burner, regulated by a clockwork machine. The gas and the mechanism would be serviced weekly by an attendant from the Granton Stores.

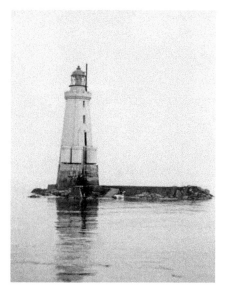

The Oxcars Lighthouse burned bottled gas when made automatic. (Collection of the Museum of Scottish Lighthouses)

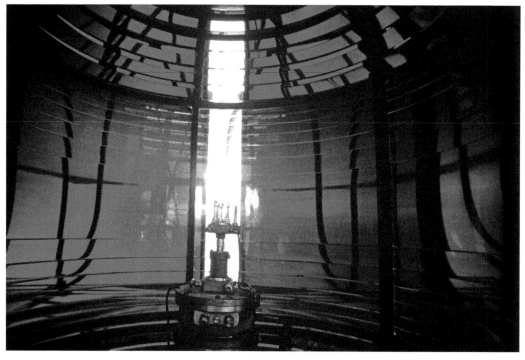

The Oxcars lens made use of red sectors of glass to further aid the mariner. (Keith Allardyce, Museum of Scottish Lighthouses)

By the end of his career, he had established about seventy-five unmanned minor lights around the coast of Scotland. These were far removed from the beauty of uncle Alan's lights. Cast iron and pre-fabricated, they were built with automation in mind. They were, in one way, a flat pack light on which sections could be added or removed to fit. These minor lights were lit with acetylene, and usually produced their beam from small fourth-order dioptric 'barrel' lenses.

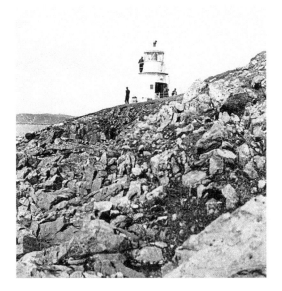

Hoxa Head minor light being supplied with gas *c.* 1910. (Peddie Collection, Museum of Scottish Lighthouses/NL Heritage Trust)

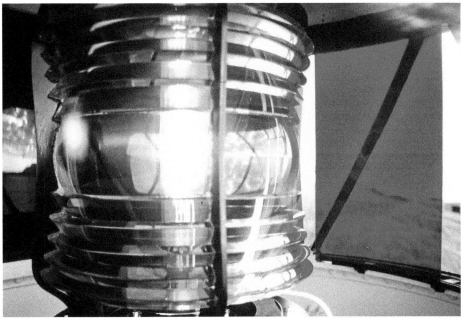

Typical fourth-order 'barrel lens' used in Hoxa Head minor light. (Keith Allardyce, Museum of Scottish Lighthouses)

The pace of building manned stations slowed down under David Alan's tenure with only twenty-six lights being built between 1885 and 1937. He did, though, design some of Scotland's more notable lights. He designed the strangely shaped Rattray Head (1895) on the coast of Aberdeenshire. Its solid base was designed to house a powerful fog horn, the first time this had been achieved at a 'rock' tower.

The lighthouse at Sule Skerry, first lit in 1895, was built 35 miles west of Orkney. It was recognised by the *Guinness Book of Records* as Scotland's most remote manned station. This isolated island had been populated only by the birds before the arrival of the keepers.

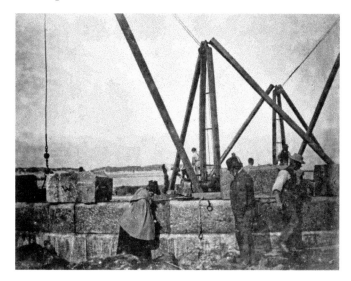

Charles Stevenson overseeing the laying of the first courses at Rattray Head, 1892. (Collection of the Museum of Scottish Lighthouses)

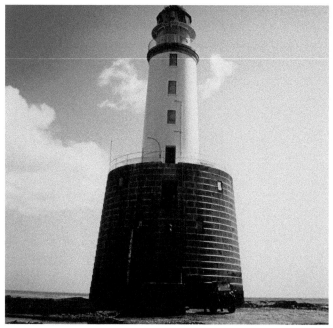

Rattray Head was completed in 1895 to house a major foghorn. (Collection of the Museum of Scottish Lighthouses)

Sule Skerry was officially the UK's most isolated rock station. (Collection of the Museum of Scottish Lighthouses)

Flannan Isle

The Flannan Isle Lighthouse was built on an uninhabited outpost some 20 miles west of the Isle of Lewis between 1895 and 1899. It was to become David's most notable station not by design, but by the famous unsolved disappearance of its three keepers in December 1900. Lighthouse tender *Hesperus* arrived at the station to deliver stores and undertake crew change but no signal was forthcoming from the station.

The Flannan Isle Lighthouse, with the ancient chapel in the foreground. (Ian Peattie Collection, Museum of Scottish Lighthouses)

Keeper Joseph Moore's hair was said to have turned grey overnight after his experience on the Flannan Isles. (By kind permission of Joseph Moore's descendants)

Relief keeper Joseph Moore attempted to land, but no one came from the station to aid his landing. After making his way to the station, he searched the whole island and found no sign of the keepers Ducat, Marshall or McArthur. Two sets of oilskins were missing, and this coupled with the storm damage caused to the west landing led Superintendent Muirhead to conclude that it was probable that two keepers had gone to salvage landing gear when they were swept away by a freak wave. The third keeper left the lighthouse to assist, but was himself taken away by the waves.

Giant Lenses

As a brand new station, the Flannans had been crowned with a relatively new design of giant lens called a hyper-radial. The lenses had a focal diameter of 1,330 mm, dwarfing the first orders. The successful design was first proposed by Irish lighthouse engineer John Richardson Wigham as early as 1872. Thomas Stevenson, already engaged in a long running feud, claimed to have discussed the concept three years before.

The hyper-radial was the pinnacle of lighthouse lens illumination, producing a light, depending on the illuminant and conditions, for anything between 25 and 35 miles. David Alan was particularly keen to introduce them to Scottish lights, designing nine between 1892 and 1910 for new stations and for upgraded stations such as Pladda (1901), Kinnaird Head (1902), Bell Rock (1902) and Buchan Ness (1910). Of those nine, only two remain in their towers at Kinnaird Head and Hyskeir.

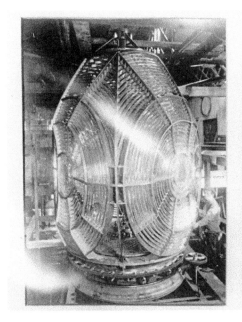 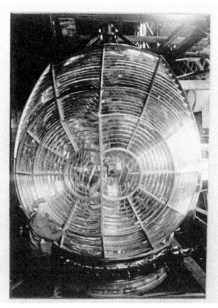

The Flannan Isle lens in the Chance Factory, 1899. (Collection of the Museum of Scottish Lighthouses)

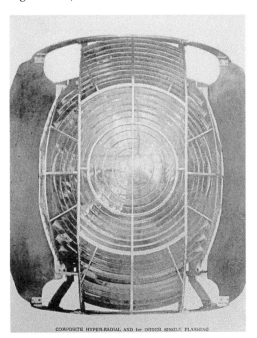 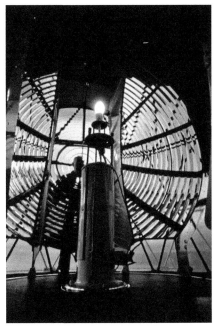

Left: Composite first-order/hyper-radial lens from Buchan Ness Lighthouse by the Chance Factory, 1910. (Collection of the Museum of Scottish Lighthouses)

Right: The lens at Kinnaird Head is one of only two hyper-radials to remain in its original tower. (Keith Allardyce, Collection of the Museum of Scottish Lighthouses)

Charles Stevenson continued to assist his brother with the family firm, seeing many of his inventions used in David's designs. In 1895, he developed the equiangular prism that further condensed the beams, causing less loss of light. Another invention was the triple parabolic flashing reflector. The mirrors had a parabolic curve that would magnify and condense the light to the focal plane, creating a bright flash when rotated. This was usually rotated on a mercury bath as opposed to bearing system.

Charles Stevenson (1855–1950).

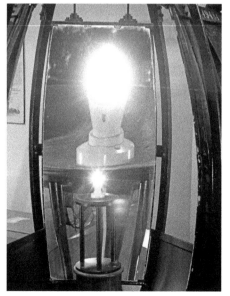

The parabolic curve of the reflectors magnified the original light source, as demonstrated in this image. (Collection of the Museum of Scottish Lighthouses)

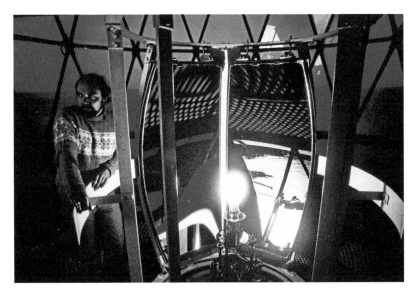

The reflectors at Girdle Ness Lighthouse were arranged to give a double flash every twenty seconds. (Keith Allardyce, Collection of the Museum of Scottish Lighthouses)

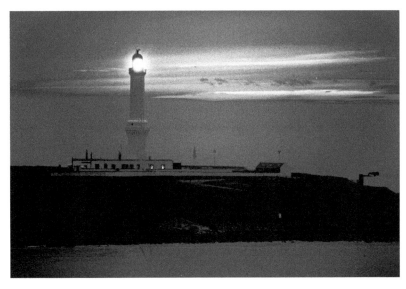

The flash created from the reflectors at Girdle Ness. They were later replaced with the sealed beam array. (Keith Allardyce, Collection of the Museum of Scottish Lighthouses)

The lamps would also become more powerful with the introduction of the incandescent paraffin vapour lamp in 1904. This type of lamp, which came in three sizes (35 mm, 55 mm and 85 mm), essentially operated like a Tilley lamp: the paraffin oil was heated under pressure into a gas, burning off under a mantle to create a bright light. This new lamp created a brilliancy about seven times greater than the multi-wick burners. So efficient was the light that it would be used well into the 1970s at many stations. The Bass Rock, Ailsa Craig and Copinsay were still operating paraffin lamps in the 1980s.

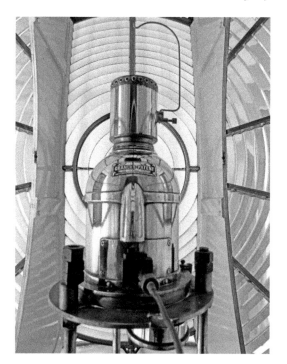

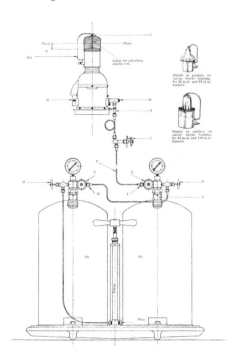

Left: An 85 mm incandescent lamp in the hyper-radial lens assembly at Kinnaird Head. In 1908, David A. Stevenson wrote that this combination made Kinnaird Head Scotland's most powerful light.

Right: The paraffin was pumped to the burner by the keeper before being vaporised in the heated lamp.

The paraffin vapour was burned in a mantle. The Bass Rock used a paraffin lamp into the 1990s. (Keith Allardyce, Collection of the Museum of Scottish Lighthouses)

Radio

Due to the locations of some stations, both brothers saw the potential of radio communication and technologies at the turn of the century. David had reportedly considered introducing wireless telegraphy for communication purposes as early as 1898, and had considered a wireless fog signal from 1904. Charles had been experimenting with such technologies from the early 1890s with varying success.

In March 1929, the first wireless fog signal was introduced at Kinnaird Head, transmitting a signal of MMK in Morse code. Another was soon established at Sule Skerry and other stations. Wireless telegraphy was introduced from the early 1920s, allowing improved communications with the hitherto almost unreachable rocks.

In the same year the radio signal was established in the lighthouse service, the Stevensons built their last manned station at Esha Ness, Shetland. The station was unusual in that it was built as a one-man station. The other oddity was the square structure of the tower and lantern, built of concrete and emulating his earlier tower built at Duncansby Head near John o' Groats (1925).

These were the last major works of the Stevenson family in Scottish lighthouses. David Alan retired as engineer to the Board in March 1938 at the age of eighty-three, bringing an end to the family's 150-year history at the helm of the NLB.

Building of Duncansby Head Lighthouse, 1922. (Collection of the Museum of Scottish Lighthouses)

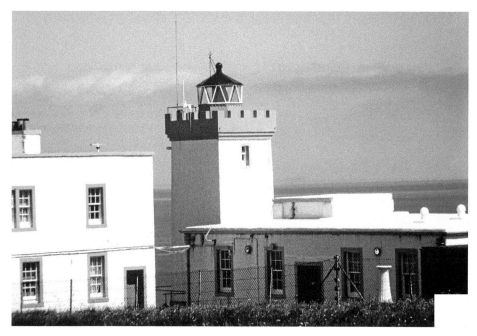

Duncansby Head Lighthouse was built square so the fittings would not need to be custom made.

Esha Ness Lighthouse was the last major light built by a Stevenson. (Ian Cowe)

Chapter 6

Lighthouses at War

The nightly routines of the lightkeeper underwent only very gradual change between the nineteenth and early twentieth centuries. The service would be forced to undergo its most abrupt changes when the nation was plunged into national crisis during the World Wars.

First World War

With the outbreak of hostilities in 1914, the normal routines were broken and the majority of coastal lights and beacons extinguished. As R. W. Munro pointed out, this was a necessity as enemy forces could use the lights for their own means: the accurate laying of sea mines. Although most lights were off, the keepers would remain at their post awaiting further instruction from the Admiralty. Major lights could be exhibited upon request although normally with a dimmed light.

The most notable incident of the war occurred in October 1915 when a 10,850-ton battle cruiser, HMS *Argyll*, run aground on the Bell Rock reef. The ship's Captain had requested the light be exhibited at very short notice, but the Bell Rock's keepers, having no radio signal and cut off by bad weather, did not receive the order. The keepers were

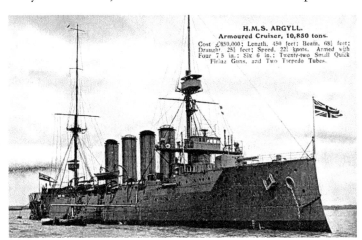

Postcard of *HMS Argyll*, launched 1904.

A rare image of the *HMS Argyll* on the Bell Rock reef, 1916. (Collection of the Museum of Scottish Lighthouses)

oblivious to the collision until they went to attend a scheduled shift. Upon seeing the warship, they took shock believing the station to be under attack from the enemy. There were no casualties.

When the lights were re-established in 1918, the normal routines would fall back into place until once again war interrupted.

War Planning

With the outbreak of war in September 1939, the NLB was to face the challenges of conflict in the air and in the sea. It is clear that war was not unexpected as secret letters were dispatched from George Street as early as April 1939 preparing for an outbreak of hostilities.

These letters arrived at stations marked top secret, for the attention of the principal keepers only. This letter contained a second sealed envelope with an accompanying note explaining the sealed letter was to be kept safe and opened only after receiving a telegram simply instructing 'Institute Phase 1A'. The second letter was clear: 'Extinguish your light now.'

The lights were not, however, switched off entirely. They came under the strict control of the Admiralty and exhibited only at certain times. These orders could now be better controlled with the advancing use of radio communication. The air-raid siren would be the only override to an Admiralty Order.

Although exhibited with great caution, lights nearer population centres were now being viewed with suspicion by local communities. Not only were the lights believed to guide the Luftwaffe to town, but in the day, distinctive white towers could be used as markers. This led the NLB to order that keepers cease to lime wash towers. Concern was so high at Montrose that Scurdie Ness Lighthouse was painted black to prevent it being used as a day-marker.

NORTHERN LIGHTHOUSE BOARD,

84 GEORGE STREET,

EDINBURGH, 2. 3 APR 1939

SECRET.

Sir,

Your authority for opening this letter has been the receipt by you of the following telegram from the Admiralty:-

"Institute Phase I A "

I have now to instruct you as follows:-

(1) Light. To be extinguished forthwith.

(2) Fog Signal. To be put in operation when necessary as heretofore.

These instructions will stand pending the receipt of further orders from this Office, or from the Admiralty or from a competent Naval Authority.

Your obedient Servant,

The Principal Lightkeeper,

SUMBURGHEAD Lighthouse.

Secret letter instructing the keeper to extinguish his light, issued April 1939. (Collection of the Museum of Scottish Lighthouses)

The monthly return book from Kinnaird Head shows the chaotic nature of lighting and extinguishing during the war. (Collection of the Museum of Scottish Lighthouses)

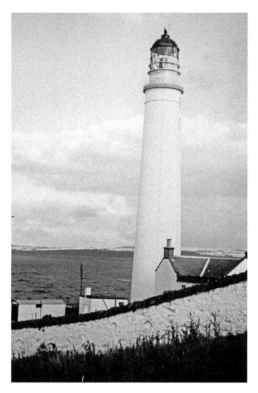

Scurdie Ness Lighthouse was painted black during the war due to concerns from the local community. (Ian Peattie Collection, Museum of Scottish Lighthouses)

Attacks

The Second World War clearly had a greater impact on the service than the First World War. Many areas of the coast were peppered by enemy sea mines, cutting off the supply to rock stations and island stations. The Monach Light, west of North Uist, was abandoned in September 1942 due to wartime difficulties in supply. The Assistant Superintendent wrote, 'The attending boat trips were few and far between and the provisions when they did reach the lighthouse, after lying for weeks at Bayhead, were frequently found to be useless.' It would be abandoned for the next fifty years.

Many lighthouses were deliberately targeted by the Luftwaffe during the course of the war, particularly on the east coast after the fall of Norway. Kinnaird Head, Pentland Skerries, the Bell Rock, Rattray Head and both Fair Isle lights were targeted to varying degrees.

Mabel Stuart, whose father served at Kinnaird Head, recalled the lantern being shot at by a passing plane in 1941. The Bell Rock light was targeted on three separate occasions, one of which saw the station bombed and lantern machine-gunned, causing damage to the lens. Similarly in September 1941, bombers targeted Rattray Head, circling the station, dropping three bombs and shooting at the lantern.

The worst affected of all the stations was Fair Isle South, south of Orkney, which suffered two fatal attacks. First, in September 1941, the wife of the assistant keeper was killed when an enemy aircraft opened fire on the station. Second, in January 1942, the wife and young daughter of the principal keeper were killed when the station suffered a direct hit, destroying the accommodation.

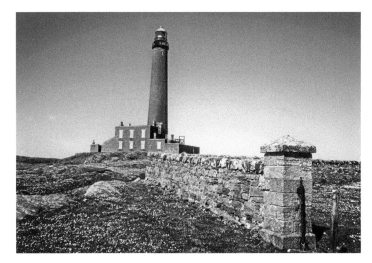

Monach Lighthouse, built in 1864, is located on the remote island of Shillay.

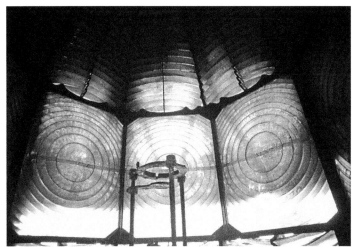

When the lighthouse was abandoned in 1942, the lens was left in the tower for the next fifty years. (Keith Allardyce, Museum of Scottish Lighthouses)

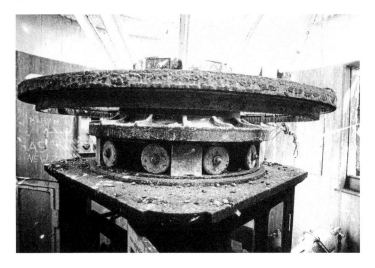

The winding apparatus at Monach, having been abandoned. (Keith Allardyce, Collection of the Museum of Scottish Lighthouses)

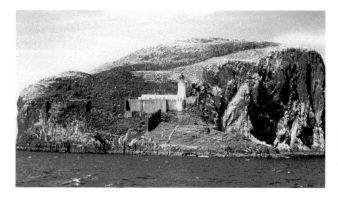

Bass Rock Lighthouse was abandoned during the war, but re-established in 1946. (Ian Cowe)

The Rattray Head lens was badly damaged by machine gun fire during the war. (Collection of the Museum of Scottish Lighthouses)

Bullet damage to the Bell Rock hyper-radial lens panel now on display at Signal Tower, Arbroath. (By kind permission of Signal Tower Museum)

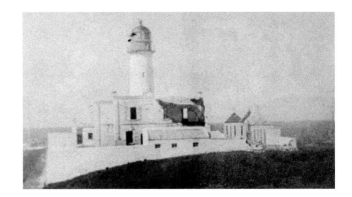

Bomb damage to the Fair
Isle South Lighthouse, 1942.
(Collection of the Museum of
Scottish Lighthouses)

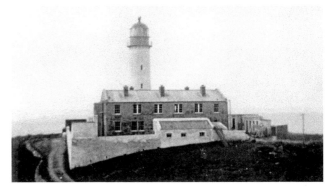

The cottages were rebuilt
after the war, as seen in 1949.
(Collection of the Museum of
Scottish Lighthouses)

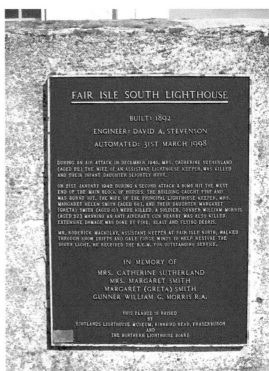

A memorial was erected to the Fair Isle
South victims in 1998 before the station
was automated.

Invasion Plans

Not only did the lights of the islands face bombing raids, but after the fall of Norway, there was a real fear that the Orkneys and Shetlands were at risk of invasion. As such the Board put into place contingency plans to ensure the lights could not be used by the enemy.

Secret correspondence to Sumburgh Head instructed the keepers that in the event of invasion 'the lighting equipment should not be destroyed, but should be temporarily put out of action'. Keepers were to bury or otherwise dispose of any lamps or crucial lamp parts, waste all oils that could be used by the enemy, and if more time was afforded essential parts of the clockwork machinery were to be removed to prevent the required rotation of lenses.

The free movement of the keepers could also be an issue during this total war. As the service was aiding the Allies, the NLB were issuers of employment certificates that were produced as a means of identity and a demonstration that the men were undertaking an essential service.

The Second World War was a testing time for the NLB, but the keepers stuck to their watch and did everything possible to aid the war effort. For services undertaken, light keepers were eligible for the Defence Medal.

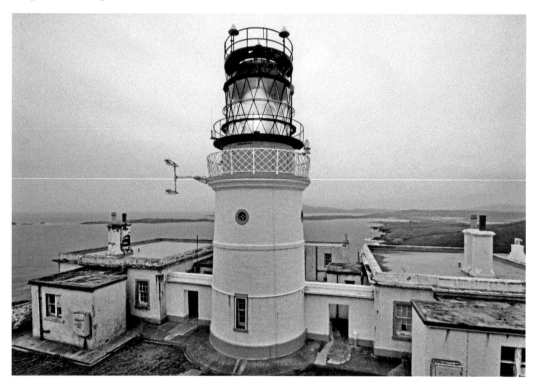

Sumburgh Head Lighthouse, Shetland. (Ian Cowe)

Page 2 D.R. Form 12

CERTIFICATE OF EMPLOYMENT

In Essential Services in War

This is to certify that *Daniel Foster Mitchell*

is a *British* subject employed in essential war services by *Commissioners of Northern Lighthouses* of *84 George Street Edinburgh* in the capacity of *Supernumerary Lightkeeper*

It is requested that he may be afforded all facilities necessary for the discharge of his duties in the above capacity.

Signature

Date of Issue *7th October 1943*

Page 3

General Serial № 33866

Employer's Reference No. *CNL. 291*

Signature of Bearer *Daniel F. Mitchell*

Postal Address of Bearer

Inchkeith Lighthouse

Leith P.O.

Supernumerary keeper Dan Mitchell's work permit, showing his duty was essential to the war effort. (Collection of the Museum of Scottish Lighthouses)

A wartime photograph of assistant keeper George Craigie, who was present at Fair Isle South. The standard white caps had been abandoned. (Collection of the Museum of Scottish Lighthouses)

Chapter 7

The Lightkeeper

At the heart of the service were the lightkeepers who would undertake their nightly vigils around the coast of Scotland for over 210 years. The profession of the Scottish lightkeeper developed over the course of the nineteenth century as a job of duty, technical ability and strength of character. A sense of duty was paramount as on the shoulders of the keepers lay the lives of men.

For that reason, discipline was always strict to ensure standards were maintained. The Stevenson engineers were particularly keen on undertaking surprise inspections of lighthouses in order to check standards were kept high. Punishment would reflect the seriousness of the offence. A keeper could be fined even for failing to keep a clean lighthouse including the non-essential brass work.

Brasses were always highly polished and even checked by Commissioners during their visits. (Keith Allardyce, Collection of the Museum of Scottish Lighthouses)

Serious offences would be punishable with instant dismissal from the service. This was reserved for any offence that prevented the keeper from undertaking his duty. If the keeper failed to keep the light burning or if he allowed a rotating apparatus to stand still, he would be dismissed. Keepers would undertake four-hour shifts during the night ensuring the light remained brilliant.

The lenses were rotated by a clockwork machine, emulating that of a grandfather clock with a weight dropping down the tower. It was necessary for the keeper to wind the weight back to the top of the tower before it ran out of chain. This would generally mean the mechanism was wound every thirty to forty-five minutes depending on the tower.

A keeper winds the clockwork machine at Bass Rock Lighthouse. (Keith Allardyce, Museum of Scottish Lighthouses)

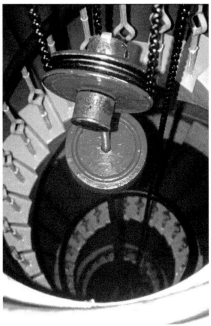

The dropping weight regulated the rotation of the lens. The rotation had to be exact, or a false character would be exhibited.

A built-in clock would ring a bell to alert the keeper to wind the mechanism every half hour. (Keith Allardyce, Museum of Scottish Lighthouses)

Of course, the Engineer and the Commissioners could not be at every station to ensure all were running smoothly. This is why in the 1820s, Robert Stevenson introduced the two-keeper system as opposed to the family-run lights. In his own words, 'The lightkeepers, agreeing ill, keep one another to their duty.' This grew to an expectation that the keeper would report any offences by colleagues to number 84.

There was a great scandal at Sumburgh Head in 1871 when the light went out and the Principal failed to report it. After investigation, the Commissioners exposed a deal between the keepers not to report the misdeeds of one another. On exposing this deal, the guilty assistant was sacked. The long serving but complicit Principal was treated leniently: permanently demoted to the rank of assistant until retirement.

Although discipline was severe, the keepers enjoyed a fairly comfortable and respectable life through their employment. Robert Stevenson introduced a uniform to the service to 'raise [the keeper] in his own estimation, and in that of his neighbour'. The uniform developed was to mirror that of a naval officer with brass buttons and peaked caps. The badge on the cap would distinguish between the two main ranks: Principal and Assistant.

Accommodation was provided for the keeper and his family, which they would enjoy rent free. These houses would be heated with an allowance of 4 tons of coal per year, and latterly electricity bills were met by the Board. These houses were also furnished and, according to Robert Stevenson, they were kept in the 'best style as shipmasters; and this is believed to have a sensible effect upon their conduct'.

Although generous, this system of tied houses added another element of control over the keeper. The Commissioners retained the right to send keepers to any lighthouse in Scotland or the Isle of Man at their discretion. As the house went with the post, they would have to move. This system meant that keepers would be relocating on a regular basis. There was no standard term but you would expect to be moved every three to seven years. This practice was again carried out until the end of the manned service.

The son of one keeper recorded it as being, 'always a disruptive problem ... all belongings, furniture, bedding, crockery, toys, household goods – everything – had to be packed in boxes and then crated for transfer by many different means of transport'.

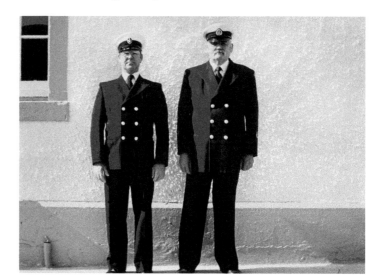

Assistant keeper Dave McIllwraith (left) and principal keeper Bruce Brown (right) in full uniform at Duncansby Head. (Keith Allardyce, Collection of the Museum of Scottish Lighthouses)

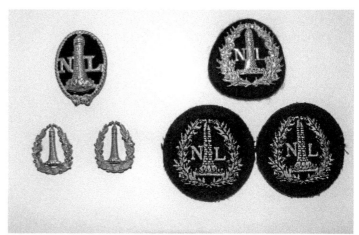

Insignia of the lightkeepers: top left shows an assistant keeper's cap badge. These were worn by principals before *c.* 1930, accompanied by the PLK's collar badge. The insignia top and bottom right denote a principal keeper. (Photograph by Katie MacKinlay)

Principal keeper James Shanks and his wife at their Northern Lighthouse Board cottage at Kinnaird Head. (Keith Allardyce, Museum of Scottish Lighthouses)

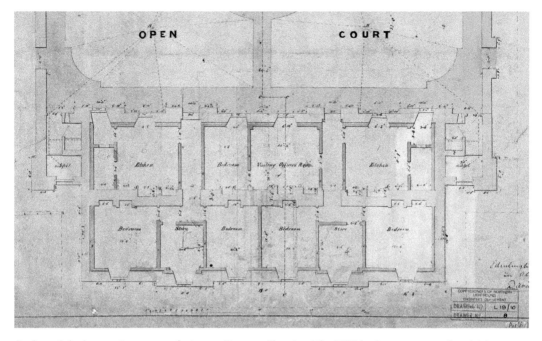

A plan of the keepers' accommodation at Covesea Skerries. The PLK had extra rooms for visiting officials. (Northern Lighthouse Board)

ASSISTANT LIGHTKEEPER.

Flannan Isles LIGHTHOUSE,

2nd Sept. 1899.

I hereby acknowledge that, on entering upon the duties of Assistant Lightkeeper at this Station this day, the various articles of Furniture and Utensils specified for the Assistant's and Artificer's room, in the Inventory Book of the same, were handed to me, and the same found to be correct.

Sign here ☞ *Thomas Marshall*

Houses were furnished by the board. On arrival, keepers would sign to acknowledge the items of furniture at this station on arrival. It would all have to be accounted for on leaving. (Collection of the Museum of Scottish Lighthouses)

Not only were you unaware of your period of duty, but you had no clue to where you would be sent next until the official notification arrived: it could be shore, island or rock.

The lucky keepers would be based on land where the duties were generally lighter and the setting more conducive to family life. The worst stations for the family were the remote island stations such as the Monach and the Fair Isle. Some of these remote stations, such as Holy Isle and Cape Wrath, still had no running water into the 1970s.

The rock stations were considered the worst by most keepers. For the majority of the service, the men would be taken to their destinations by lighthouse tender, the *Pharos*, *Hesperus*, *Pole Star* and *May* undertaking such trips. Keepers would be swung on to the station clinging to a rope and pulley, being delivered with the fresh rations of food, barrels of water and oil and the mail all in quick time.

For six weeks, they were cooped up with two other keepers undertaking a never-ending routine of shifts. Being located on otherwise uninhabited reefs or islands, this often led to boredom. There were the less sociable keepers who would take to their beds when off duty but the majority would find a hobby: painting, bird watching, model making, knitting and even sunbathing were all commonly carried out before the advent of the television.

The lights may have been extinguished during the day but that would not mark the end of the duties. As soon as the light went out, the preparations for the next evening would begin. The paraffin oil would be measured for the next evening's duties and the lamp checked. Paraffin does not burn clean, leaving the lens covered in a greasy soot. The lens would, therefore, require cleaning every day or second day depending on the season. The introduction of electric lights reduced the cleaning dramatically.

During summer, the light would be on for shorter periods and so the amount of idle time would naturally increase. In order to combat this, the keepers would have additional duties. Keepers were responsible for the annual maintenance of the station; that would include painting the towers and any dwellings. The stations and the apparatus were always kept immaculate in the age of the keepers.

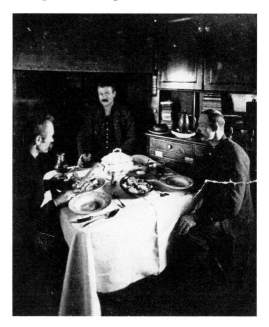

The keepers of the Bell Rock in their kitchen diner *c*. 1900. (Collection of the Museum of Scottish Lighthouses)

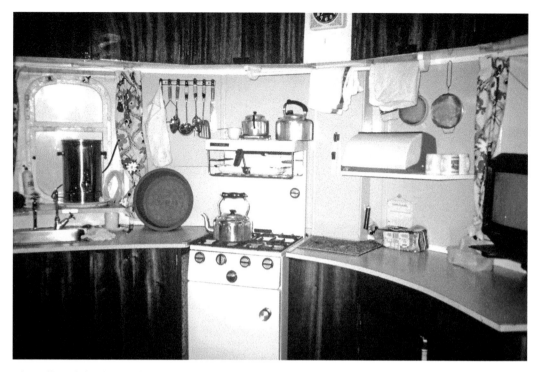

The Bell Rock kitchen in the 1980s. (Ian Peattie Collection, Museum of Scottish Lighthouses)

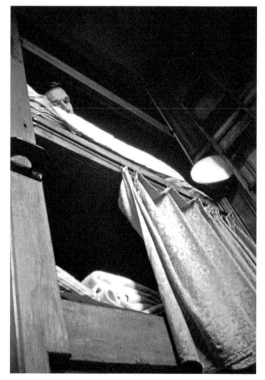

Keepers at rock stations could expect little privacy. The keepers at Sule Skerry shared accommodation, as seen with this bunk bed. In pillar towers, the beds were built into the curve of the tower. (Keith Allardyce, Collection of the Museum of Scottish Lighthouses)

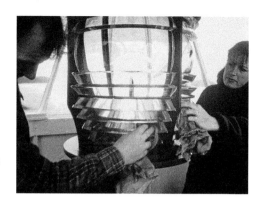

Lenses would be cleaned every morning when paraffin was being burned. A hyper-radial could take a couple of hours to clean in winter. (Keith Allardyce, Collection of the Museum of Scottish Lighthouses)

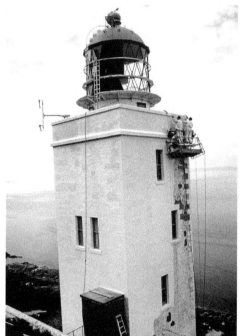

The distinctive square tower at Holy Isle being painted in a typical fashion. (Keith Allardyce, Collection of the Museum of Scottish Lighthouses)

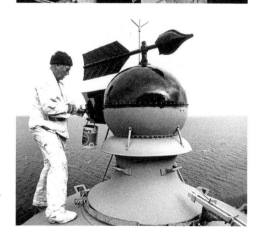

Painting the weather vane on the lantern dome. (Keith Allardyce, Collection of the Museum of Scottish Lighthouses)

From 1867, keepers were also responsible for recording the weather, the returns being sent to the Met Office. Lighthouses were equipped with their own instruments to measure wind speed, rainfall and temperature. Due to their locations, the returns were a valuable contribution to the Met Office data. The keepers were paid an additional allowance to their pay for undertaking weather duties.

It was often said that lightkeeping was not just a job, it was a way of life. As the twentieth century wore on it was a way of life increasingly under threat.

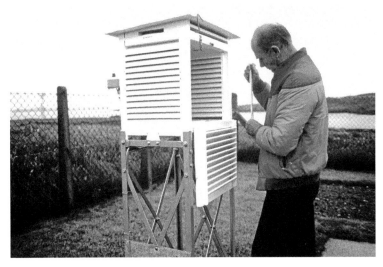

Thermometers were kept in a Stevenson screen, an invention by Thomas Stevenson, to read accurate temperatures without wind chill. (Keith Allardyce, Collection of the Museum of Scottish Lighthouses)

A principal keeper battles against the wind at Sule Skerry. (Keith Allardyce, Collection of the Museum of Scottish Lighthouses)

Chapter 8

Lighthouse Tenders

From the beginning of the service in 1786, the NLB required the use of tenders to carry out their work. Due to the remote locations of stations, boats were the only means of supplying construction materials for building projects and of course supplying food, water and fuel for operational lights.

There have been many vessels in the service of the Board, but the names that are synonymous with the organisation are the *Pharos*, *Pole Star*, *Hesperus*, *Fingal* and *May*. As the vessels were upgraded, the names were often reused. For example, there has been a *Pharos* supplying lights since 1799, the tenth *Pharos* now serving the Board.

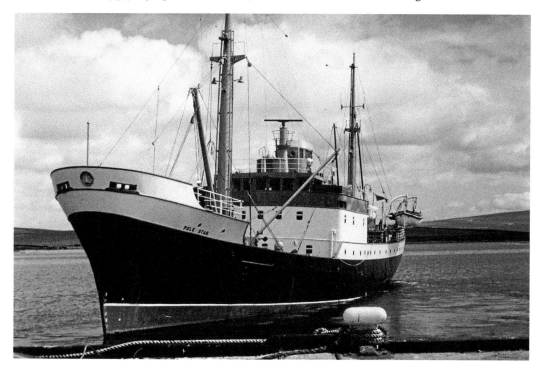

Pole Star (III) served the board from 1961 to 1993. Another *Pole Star* was named in 2000. (Ian Peattie Collection, Museum of Scottish Lighthouses)

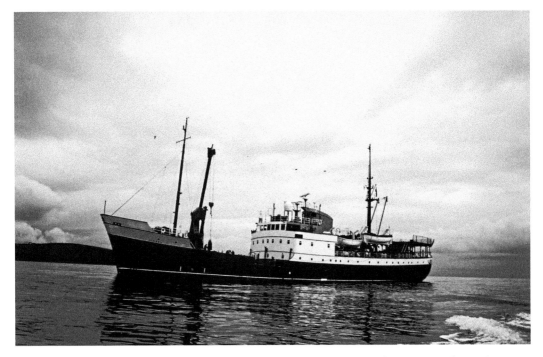

Fingal served 1964–2000. After sixteen years as *Royal Windsor,* the vessel was renamed *Fingal* in 2016 to be converted to a hotel beside the Royal Yacht *Britannia.* (Ian Peattie Collection, Museum of Scottish Lighthouses)

Supplying Lights

Steered by the Master, the main purpose of the tender was to maintain a supply chain to Scotland's lighthouses in never-ending voyages around Scotland's coast. Their arrival at a given station would be dictated by the crew rota: they would normally visit every fortnight to change a keeper.

The keeper was not delivered alone. He would go with rations of fresh food to stock up the station. If he was unfortunate enough, he would be on the six-monthly trips to supply water or fuel to the station, which was among the most difficult tasks to carry out.

In order to carry out a landing the master would 'do what no ship was intended to do': steer towards a lighthouse. The smaller ribs would then be launched and make their way to a gully or landing platform laden with the materials to be landed.

They would be greeted at their destination by the keepers, who would secure the rib by rope and then set about retrieving the cargo using a system of pulleys built at the landing platform. This would include the keepers, who were swung on to the platform and the other off.

The keepers were then required to transport the supplies to the light as quickly as possible. In terms of rocks like Skerryvore and the Bell, this would involve carrying the supplies up a 20-foot ladder. Heavier items would progress higher in the lighthouse pulleys. Larger rock stations such as Sule Skerry and Muckle Flugga had tracks laid so that supplies could be easily transported to the station.

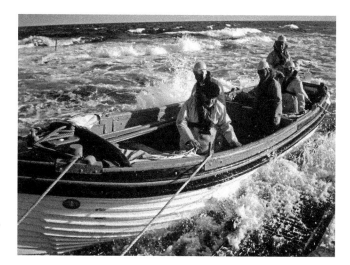

Landing craft/ribs were used to bring supplies and keepers from the tender to the station. (Keith Allardyce, Museum of Scottish Lighthouses)

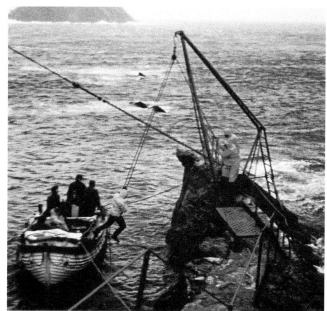

Keepers would be swung on and off stations on the same pulleys that delivered supplies. (Ian Peattie Collection, Museum of Scottish Lighthouses)

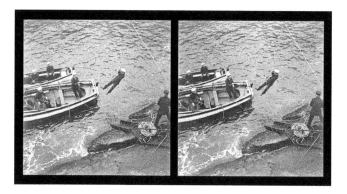

Commissioners leaving Sule Skerry *c.* 1910. (Peddie Collection, Museum of Scottish Lighthouse NL Heritage Trust)

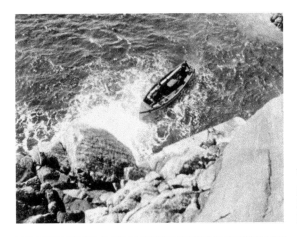

View from the Flannan Isle west landing platform *c*. 1910. (Peddie Collection, Museum of Scottish Lighthouses/NL Heritage Trust)

The landing platform at Muckle Flugga being battered by the waves in adverse conditions. (Ian Peattie Collection, Museum of Scottish Lighthouses)

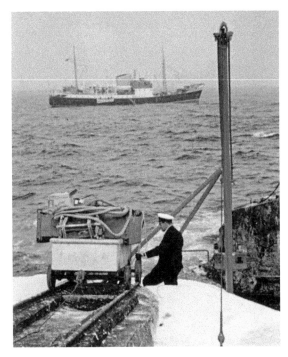

Tracks were used to cart supplies from the landing platform to Sule Skerry. *Pole Star* is in the distance.

Signalling

Landing by boat was dependent on the seas. If the weather was rough, no landing would be made. This information would be communicated to the tender from the station. Before radio, communication was maintained by flag signalling – the most important flags being for landing or no landing.

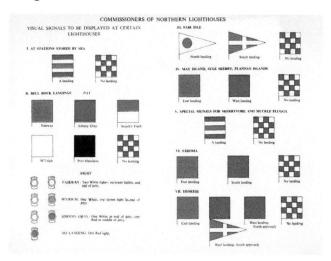

Diagram of a number of flag signals used at different lighthouse stations. (Collection of the Museum of Scottish Lighthouses)

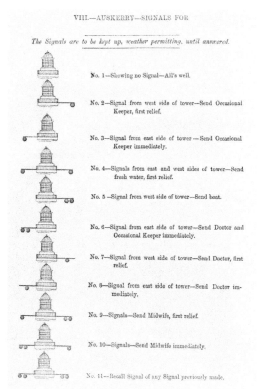

Station signals and commands for the Auskerry boatman. (Collection of the Museum of Scottish Lighthouses)

A secondary system of signals was in place for island stations: these were supplied by a boatman and messages would be sent using a signalling bar at the top of the station. Over the decades, the signals developed more and more to include a diverse number of messages.

Radio signalling from the 1920s made the system much simpler and saw an end to the need for flags and other signals.

Buoywork

In addition to other duties, the tenders were responsible for maintaining and refuelling the buoys floating in Scottish waters. After 1900, the buoys would be filled with acetylene gas, which they would burn over a period of three months – day and night. The tender would then return to the buoy to either refuel or replace it.

The red buoy lantern contained a sixth-order lens, and emitted a flash created by an AGA gas flasher. The flasher device could divide a litre of acetylene into 10,000 small flashes of light in three distinct flash patterns.

The tenders were equipped to lift the buoys from the water as occasionally they would require cleaning and servicing in the depot. In order to save damaging the fragile lanterns and lenses, large baskets were placed over the lanterns before lifting.

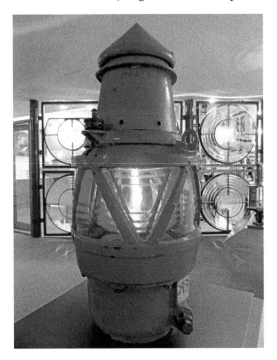 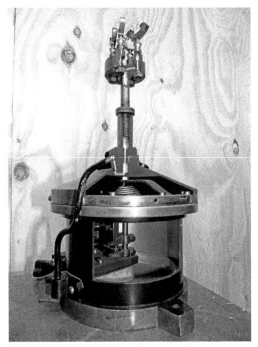

Left: A typical buoy lantern displaying a red light. (Collection of the Museum of Scottish Lighthouses)

Right: An AGA flasher unit would split the acetylene to create a flash sequence for the buoys. This also saved on gas consumption. (Collection of the Museum of Scottish Lighthouses)

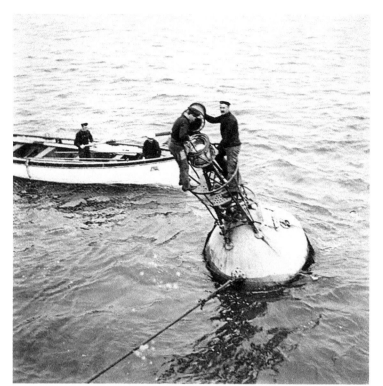

Crew members from the lighthouse tenders tend to a buoy *c.* 1910. (Peddie Collection, Museum of Scottish Lighthouses/NL Heritage Trust)

Tenders were equipped to lift buoys from the sea, as seen on the *Fingal c.* 1980. (Ian Peattie Collection, Museum of Scottish Lighthouses)

When removed, the buoys would be returned to land for servicing at the supply depots in Granton, Stromness or Oban. These depots were of crucial importance in supply logistics. Their work went beyond the buoy yard, with staff ensuring that every need of the men on their most remote stations was met.

Granton was the main lighthouse depot; however, now all operations come through Oban. (Keith Allardyce, Collection of the Museum of Scottish Lighthouses)

These enamel plate labels were used for logistics to separate stores at Granton for particular lighthouses. (Keith Allardyce, Collection of the Museum of Scottish Lighthouses)

Buoys were serviced and cleaned at the depots, ready to be reused in the future. (Ian Peattie Collection, Museum of Scottish Lighthouses)

Inspection Voyage

The flagship of the NLB was undoubtedly the *Pharos* – often called the 'Commissioners' Ship'. In addition to serving the practical needs of the lighthouse, this ship would be in use in the summer by the Commissioners as they inspected Scotland's lights.

Every aspect of the station would be checked by the Commissioners from the lighting machinery to the paint on the walls. The keepers would be in full uniform for the arrival of the Commissioners and the flag would be hoisted ready for their visit, or even just the passing of the vessel.

Until the commissioning of the new *Pharos* in 2007, the ship's interior was fitted with lavish internal rooms, including an officers' lounge and smoking room. The deck of the ship was crowned with a highly decorated cupola.

As the twentieth century progressed, the tours became more of a tradition than an inspection. Although the keepers are now all gone, the Commissioners still tour the lights every June, often joined by their Patron, HRH the Princess Royal.

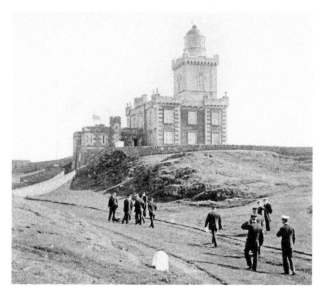

The Commissioners met for their annual meeting at the Isle of May Lighthouse – 'the Commissioners' Lighthouse'. (Peddie Collection, Museum of Scottish Lighthouses/ NL Heritage Trust)

The Commissioners onboard *Pharos* (VIII). The deck was furnished with a decorative cupola which also served as a skylight for the rooms below. (Keith Allardyce, Collection of the Museum of Scottish Lighthouses)

Chapter 9

Automation

In 1954, a catastrophic fire broke out at the Skerryvore light. Miraculously, all three keepers survived the fire, being picked from the rock by the *Pole Star* the next morning. Alan Stevenson's light had been gutted, but thankfully the structure was left largely intact. While renovations and repairs were carried out, an unmanned acetylene light was installed in the tower to take over its nightly ritual. Operating for four years, this automatic light gave the Commissioners confidence to roll out the technology elsewhere, bringing a start to the 'unwatched light' programme.

Gustaf Dalen

More than any other individual, it was Gustaf Dalen who ushered in the age of automation. In the early twentieth century, he had invented the sun valve – a device that could light and extinguish lamps by the power of the sun.

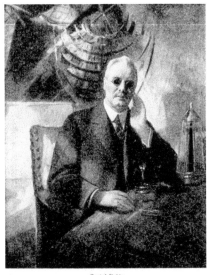

Gustaf Dalen.
Oljemålning av D. Wallin. 1929. Direktör G. Dalen, Skärsätra.

The inventions of Gustaf Dalen (1869–1937) and the AGA Co. ushered in the era of lighthouse automation.

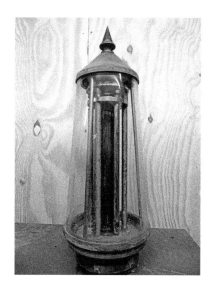

The interior of Dalen's sun valve. The black central rod would expand in the sun to cut off the gas supply to the burner. A later version was adapted to cut off electrical current. (Collection of the Museum of Scottish Lighthouses)

This picture was taken by the last keepers at Lismore in 1965. The Dalen unit made their services redundant at that station. (Collection of the Museum of Scottish Lighthouses)

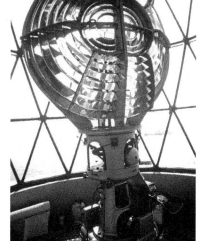

Dalen pedestals could only accommodate smaller fourth-order lenses, meaning larger optics were removed. (Ian Peattie Collection, Museum of Scottish Lighthouses)

The device worked on the concept of the absorption of heat by dark colours: the heat from the rising sun was conducted to a central black rod in the sun valve, causing it to expand downwards. In doing so, the rod restricted the supply of acetylene gas and the light became extinguished. When the sun went down the rod retracted, allowing gas flow.

The real breakthrough came with the development of the AGA Dalen mixers, which were built onto a pedestal. The explosion-proof mixers drew gas and air into an incandescent mantle to create a brighter light. The gas pressure from the mixers would also operate a pump that would spin the top pedestal to rotate the lens on mercury. The AGA lamps even developed an automatic mantle changer that could swap broken mantles with working ones.

This device could undertake the central roles of the keepers without the expense. They were widely used in the first phase of automation, being introduced to about fifteen stations in the 1960s, including Auskerry (1961), Chicken Rock (1961) and Lismore (1965). This technology saw the keepers disappear permanently from the Flannans in 1971.

Electric Lights

By 1970, another automatic technology was introduced at Fidra with the sealed beam light unit. Much more reliable, it was essentially a line of car headlamps rotating on a pedestal to create a flash sequence. It proved popular with the Board, giving out a powerful light, but it required a mains electric power supply, which on many occasions meant digging the cables to the stations.

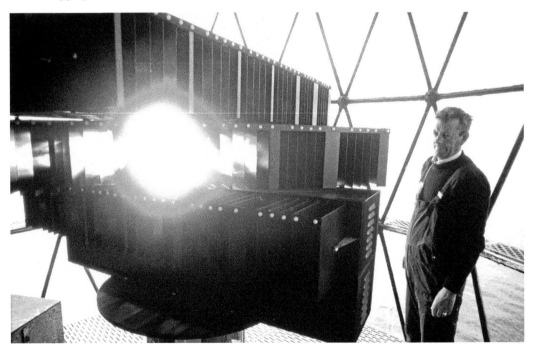

Sealed beam lamp array at Eilean Glas Lighthouse. (Keith Allardyce, Collection of the Museum of Scottish Lighthouses)

The mains electric being run to Rattray Head in 1978 in preparation for automation in 1982. (Collection of the Museum of Scottish Lighthouses)

To accommodate these changes, many hyper-radial and first-order lenses were removed from the towers, being either too large for Dalen pedestals or made totally redundant by the sealed beam units. Some lenses would be retained, in which case a dual bulb system would be installed. If one bulb failed a mercury switch would swing the spare bulb into place automatically.

Manned stations too would be brought into modernity with the widespread replacement of the old paraffin lamps in favour of mercury vapour lamps – a stepping stone to full-scale automation.

In the modern era, the NLB has upgraded lighting sources further to include LED lights, which in many cases are now powered by solar power generated on lighthouse sites. Modern buoy structures are operated by the same technologies, showing a commitment to clean energy.

Even into the era of automation, lights were still being built. Fife Ness Light, an entirely modern structure, was built in 1975 as a fully automatic light. This was required when the *North Carr* light vessel was withdrawn.

An automatic rock station was built off Shetland in 1979 called Ve Skerries. There would be no dovetailing of granite blocks; no loading of individual stones; no living on the reef. Instead, helicopters would transport huge concrete rings to the site, lowering them one on top of the other. Engineers from CHAP would ensure the rings were level and secure them with reinforcement and tensioning bars.

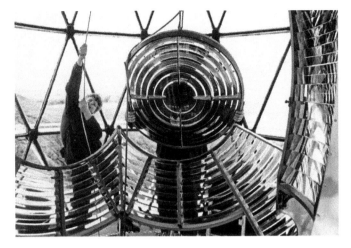

Northern Lighthouse Board employees disassemble the first-order Tiumpan Head lens in the lantern. (Collection of the Museum of Scottish Lighthouses)

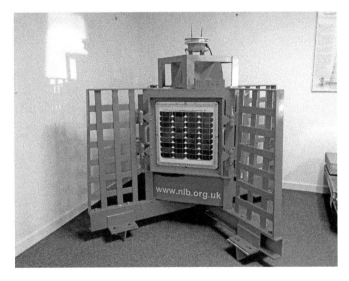

A segment of the redundant Isle of May lens is lowered down from the lantern in the late 1980s. (Collection of the Museum of Scottish Lighthouses)

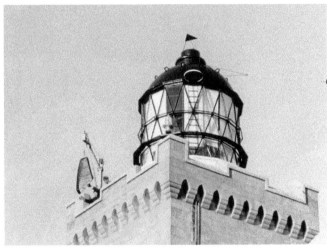

A solar-powered buoy with LED light source on top. *On loan from the Northern Lighthouse Board.*

The Fife Ness Lighthouse.
(Ian Peattie Collection, Museum
of Scottish Lighthouses)

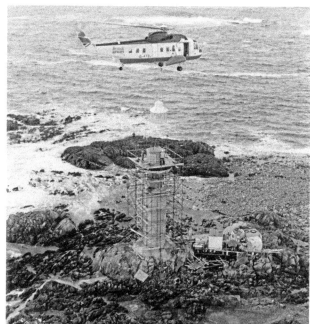

Helicopters were used to
undertake the construction of
the Northern Lighthouse Board's
last significant rock station at
Ve Skerries in 1979. (Collection
of the Museum of Scottish
Lighthouses)

The End of the Keeper

Recruitment of new lightkeepers slowed and was halted by 1981. When the NLB celebrated its bicentenary in 1986, major automatic lights outnumbered the manned stations, thirty-nine to forty-five. From this point, as the lights were made automatic the keepers were more likely to be made redundant than be 'shifted'. By March 1997, there were only five manned stations remaining: Cape Wrath, Rhinns of Islay, Butt of Lewis, North Ronaldsay and Fair Isle South.

On 31 March 1998, the Fair Isle South light became the last light to become automatic, bringing an end to lightkeeping in Scotland after 211 years. It was the end of a way of life.

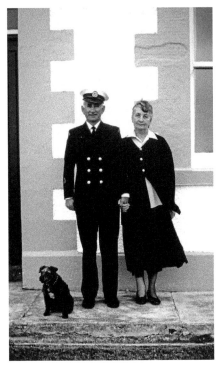

Left: Mr Michael PLK was kept on as an attendant for Butt of Lewis after he was made redundant in 1998. (Keith Allardyce, Collection of the Museum of Scottish Lighthouses)

Right: A commemorative plaque marking the end of Scottish lightkeeping after 211 years. (Collection of the Museum of Scottish Lighthouses)

Today

It is true, of course, that no light will work indefinitely without human intervention. Manpower was, and is, required. The lights are now all monitored via computer by a dedicated staff at 84 George Street, Edinburgh. If there is any fault, it will show up on their system, and '84' will make the call to their remaining employees on the ground.

As the keepers disappeared, an army of local attendant keepers and retained lightkeepers were appointed. Duties are generally light and will include cleaning the lantern glass and lens; checking radio signalling equipment is working; checking batteries; checking the bulbs; and general maintenance of the station.

A Retained Lighthouse Keeper (RLK) need not be a former keeper. There were a number of women RLKs appointed, which meant for the first time women were directly employed in a lighthouse capacity: there had been no female keepers.

The rocks require more specialist attention. The NLB still operate two lighthouse tenders, NLV *Pole Star* and NLV *Pharos*. Strictly speaking, their duties are unchanged from the days of the lightkeeper, involving buoywork, maintenance, and supply.

Working from a base at Oban, the *Pole Star* is employed mainly with buoyworking around Scotland's coast whereas the *Pharos*, commissioned in 2007, is a multi-functioning

state of the art tender. The 84-metre vessel can accommodate helicopters, which is crucial for landing supplies at some of Scotland's most remote stations. Although there are no keepers to be fed, the more remote stations still require technical supplies and maintenance to ensure the safety of the mariner.

The lights may be automatic, and the keepers gone, but the work of the NLB continues.

The attendant keeper Gordon Stewart still takes 'the boat' (a tractor) to check Rattray Head. (Keith Allardyce, Collection of the Museum of Scottish Lighthouses)

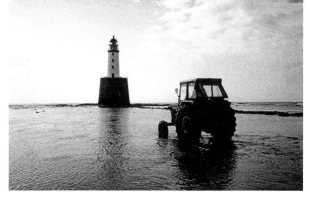

The attendant at Rattray Head is required to climb a 32-foot ladder to enter the station. (Keith Allardyce, Collection of the Museum of Scottish Lighthouses)

Mrs Leask, wife of a former keeper, was appointed attendant at Sumburgh Head. She is seen here with an automatic switch dual bulb. (Keith Allardyce, Collection of the Museum of Scottish Lighthouses)

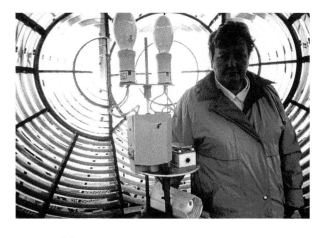

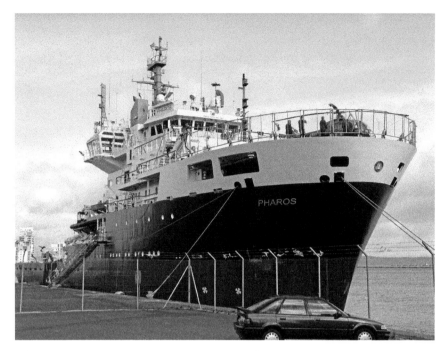

Pharos (X) was commissioned in 2007 and undertakes much of the same work as her forebears.

Helicopters are now a key part of the service, and as such the new *Pharos* is equipped with a helipad and helicopter.

Chapter 10

Afterlife

While the story of the NLB continues into the twenty-first century, the story of the Stevensons has ended. From the outside the towers still stand as their legacy and in most cases the lights still flash. But where the bones of the old service are still visible around our coasts, the story of everything that went on inside the towers has also been consigned to the past: the keepers have gone, and the houses are empty.

That is not strictly true as more and more the lighthouse towers are finding a new life. The towers may not be manned, but the keepers' cottages are not empty. They have been sold off by the Board and, due to their often beautiful settings, are popular attractions as holiday accommodation and bed and breakfasts. Before this arrangement was in place, the buildings often fell into disrepair. Under private ownership the buildings are looked after and well preserved.

This is also now the case with lighthouse towers. Lights are, slowly, starting to be extinguished and towers abandoned. Again, the Board takes a common sense approach to this, realising that towers will be better conserved as private concerns. For example, the lighthouse at Tod Head is now a private residence and the tower at Covesea Skerries (Lossiemouth) is now owned by the community and is to be made into a heritage attraction.

Corsewall Point Lighthouse has been used as a luxury hotel for many years. (Keith Allardyce, Collection of the Museum of Scottish Lighthouses)

The NLB is now committed to preserving their own history after a fairly shaky start: in 1970 the Flannan keepers were instructed to destroy their rare hyper-radial lens. Thanks to the Board, however, most lenses survive today – dotted around the country. The NLB realised their value to heritage societies and museums and in many cases they were given to the care of local communities.

The NLB have also taken greater steps to preserve the heritage of the keepers who served them loyally for over 200 years. In the early 1990s, realising that the manned service was nearing its end, they supported the establishment of Scotland's only museum dedicated to lighthouses.

The Museum of Scottish Lighthouses at Kinnaird Head, Fraserburgh, was established with the purpose of remembering the lightkeeper and the innovation of the Stevensons. The Board donated the vast majority of the museum's artefacts, showcasing the country's best display of lighthouse lenses and other artefacts.

The Board specifically arranged for Kinnaird Head Lighthouse to be preserved as Scotland's only manned station, giving valuable insights to a lost way of life. Kinnaird Head, their first light, is now visited by thousands of people each year who are in awe of what went on behind the walls of the Stevensons' lighthouse towers.

In the afterlife, the lighthouses are finding new lives and are busy once more.

The Isle of May lens being constructed at the Museum of Scottish Lighthouses.

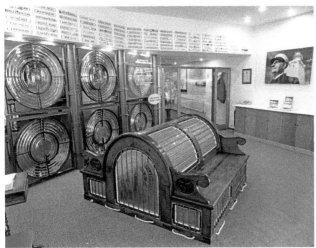

The Northern Lighthouse Board has donated many of their objects to local museums, particularly the Museum of Scottish Lighthouses, Fraserburgh.

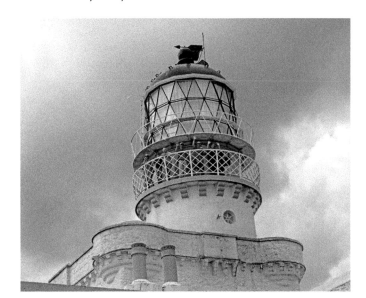

Kinnaird Head Lighthouse
at Fraserburgh was
preserved as a manned
station and is visited
by thousands of people
every year.

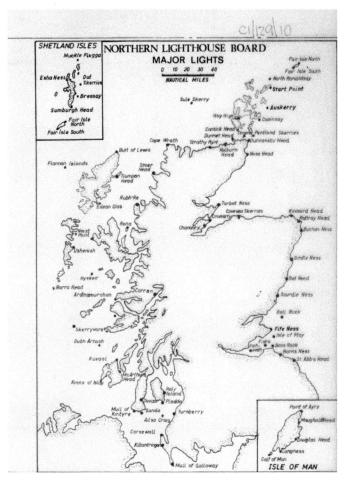

Map of Scottish lighthouses.

Bibliography

Allardyce, Keith and Hood, Evelyn M., *At Scotland's Edge* (Hong Kong: Harper Collins, 1996).

Bathurst, Bella, *The Lighthouse Stevensons* (St Ives: Harper Perennial, 2005).

Morrison-Low, Alison D., *Northern Lights: The Age of Scottish Lighthouses* (National Museums Scotland, 2010).

Munro, R. W., *Scottish Lighthouses* (Stornoway: Thule Press, 1979).

Stevenson, Alan, *Account of the Skerryvore Lighthouse* (Edinburgh: Adam & Charles Black, 1848).

Stevenson, Alan, *Memoir of Robert Stevenson, Civil Engineer* (Edinburgh: W. Blackwood & Sons, 1851).

Stevenson, David, *Life of Robert Stevenson, Civil Engineer* (Edinburgh: Adam & Charles Black, 1878).

Stevenson, David, *Lighthouses* (Edinburgh: Adam & Charles Black, 1864).

Stevenson, Robert, *An Account of the Bell Rock Light-House* (Edinburgh: Archibald Constable & Co., 1824).

Stevenson, Robert L., *Records of a Family of Engineers* (London: Chatto & Windus, 1912).

Stevenson, Thomas, *Lighthouse Illumination: Being a Description of the Holophotal System* (London: John Weale, 1864).

Sutton-Jones, Kenneth, *Pharos: The Lighthouse Yesterday, Today and Tomorrow* (Wiltshire: Michael Russell, 1985).